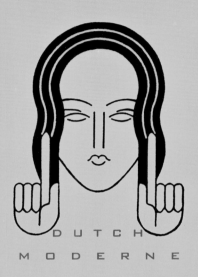

D U T C H

M O D E R N E

George E. Thompson
Modernism & Eclecticism
LCIV

GRAPHIC

DESIGN

FROM

DE STIJL

TO DECO

DUTCH H M

STEVEN HELLER

& LOUISE FILI

ODERNE

CHRONICLE BOOKS

SAN FRANCISCO

The authors are indebted to Sonia Biancalani Levethan for research assistance; Leah Lococo for design assistance; Lee Bearson for typographic assistance; and Chawa Koster for translations. Thanks also go to our friends and colleagues at Chronicle Books: Bill LeBlond, editor; Michael Carabetta, art director; Charlotte Stone, assistant editor; and Patricia Draher, copyeditor — and to Sarah Jane Freymann, our agent.

The following individuals and institutions gave generously of their time, knowledge, and materials: Piet Van Sabben of Van Sabben Poster Auctions; Mitchell Wolfson, Anita Gross, Marie Stewart, Jim Findlay, and Wendy Rosen of the The Wolfsonian Foundation; Kathy Leff of the Journal of Decorative and Propaganda Arts; Wilma Wabnitz of Wabnitz Editions and [Affiche] magazine; George Theophiles of Miscellaneous Man; Michael Sheehe of Ex Libris; Monica Strauss of M. J. S. Graphics; Helga Krempke, S. Zellweger, and Catherine Bürer of the Schule und Museum für Gestaltung Zürich; A. M. Daadler-Vos of the Stedeljik Museum; Rick Vermullen of Hard Werken; Pieter Brattinga of Form Mediation International; Piet Schrueders; Willem Zwaard of Jaarbeurs Utrecht; Vivian Greblo of the Holland-America Line; Henk Groenhoff, Jr., of Het Junior Antiquariaat; Kees Broos; Werner Lowenhardt; Fjtzen Henstra of Valeton & Henstra; Jan Tholenaar; René Kruis of Rijksinstituut voor Oorlogsdocuenatatie; Frits Knuf of Antiquariaat Frits Knuf; Peter Weiss; Joost Swarte; Greg Leeds; Seymour Chwast; Tom Bodkin; Michael Valenti; Eric Baker; Dick Maan; Ans Huijboom of Heineken Internationaal; A. M. van Lint of Douwe Egberts Van Nelle; Paul Hefting of PTT Nederland; Mieke Beumer of Universiteits Bibliotheek Amsterdam; Giovanni Fanelli; P. van Wijngaarden of Gemeente Rotterdam; I. J Blanken and J. C. van den Biggelaar of Philips Nederland NV; Marien van der Heide of Internationaal Instituut voor Sociale Geschiedenis; the folks at the New York Public Library Periodicals Division; Irving Oaklander of Oaklander Books; and James Fraser of Fairleigh Dickinson University.

Picture Credits: The Schule und Museum für Gestaltung Zürich: 10, 23 (bottom left), 23 (top right), 36, 43 (right), 49, 62, 67 (top), 78, 81, 100, 110, 112 (top left, bottom right), 113. Wabnitz Editions: 21. The Wolfsonian Foundation: 22, 23 (top left), 23 (bottom right), 26 (top), 37, 38, 39, 44, 45, 56, 57, 58 (top), 68 (top), 74, 108, 112 (top right), 120, 121. Michael Valenti: 24. Fairleigh Dickinson University, Friendship Library: 25, 31, 34. Van Sabben Poster Auctions: 26 (bottom left, bottom right), 42, 43 (left), 48 (right), 58 (bottom left, right). Internationaal Instituut voor Scoiale Geschiedenis: 27, 28, 29. The Stedelijik Museum: 46, 47 (left), 73 (left), 105. Greg Leeds: 41, 93 (top). Philips Nederland NV: 63, 65 (top), 66, 67 (bottom). Miscellaneous Man: 82 (middle). Douwe Egberts Van Nelle: 82 (left, right), 83, 97, 101, 117. Heineken Internationaal: 87 (top). Holland America Line: 106, 107. Michael Sheehe: 123. Dick Mann: 131.

Research assistance by Sonia Biancalani Levethan. Book design by Louise Fili and Leah Lococo.

IN THE 1920s, WHEN THE INDUSTRIALIZED WORLD ENTERED A MACHINE AGE, AN ELEGANT, STREAMLINED STYLE KNOWN AS ART MODERNE WAS ADOPTED BY DESIGNERS IN EUROPE, NORTH AMERICA, AND ASIA AND APPLIED TO ARCHITECTURE, FURNITURE, JEWELRY, CLOTHING, AND GRAPHICS. **INTRODUCTION** THIS WAS THE SECOND TIME IN THE TWENTIETH CENTURY THAT A DESIGN LANGUAGE PROLIFERATED THROUGHOUT THE WORLD WITH SUCH UBIQUITY — THE FIRST WIDESPREAD STYLE WAS ART NOUVEAU, WHICH BEGAN IN THE 1890s AND ENDED BEFORE WORLD WAR I. ALLOWING FOR CERTAIN INDIGENOUS VARIATIONS IN EACH OF THE NATIONS WHERE IT TOOK HOLD, ART MODERNE BECAME THE DOMINANT INTERNATIONAL DESIGN STYLE BETWEEN THE WORLD WARS. AN ORIGINAL SYNTHESIS OF CUBISM AND ANCIENT EGYPTIAN AND MAYAN DESIGN MOTIFS, ART MODERNE SPREAD THROUGHOUT POST-WORLD WAR I FRANCE, GERMANY, ENGLAND, ITALY, AND EASTERN EUROPE BEFORE EMERGING IN HOLLAND.

THIS BOOK EXAMINES HOW ART MODERNE (ALSO CALLED MODERNISTIC) GRAPHIC DESIGN WAS MANIFEST IN THE NETHERLANDS IN THE 1920s AND 1930s. ALTHOUGH DUTCH DESIGNERS DID NOT INVENT THE STYLE, THEY CERTAINLY HELPED TO POPULARIZE IT. AND WHILE THERE IS NOTHING INHERENTLY DUTCH ABOUT ART MODERNE, DUTCH DESIGNERS AND MERCHANTS ENTHUSIASTICALLY EMBRACED IT, NOT AS A RADICAL FORMAL LANGUAGE, BUT AS AN ALTERNATIVE TO BOTH TRADITIONAL AND REVOLUTIONARY GRAPHIC APPROACHES.

AS A MARKETING TOOL, ART MODERNE, WITH ITS STREAMLINED AESTHETIC, WAS SUITED TO AN INTERNATIONAL COMMERCIAL CULTURE THAT STRESSED THE IMAGE OF PROGRESS

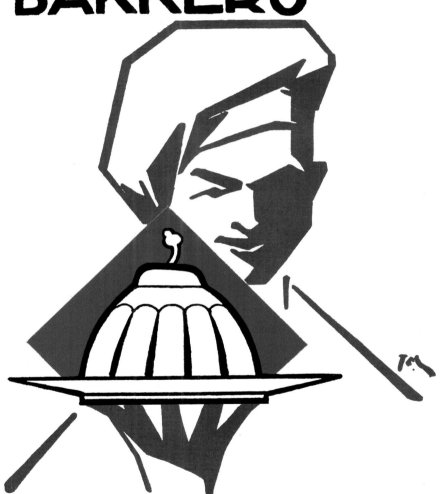

BROOK KOEK EN
BANKET BAKKERIJ
Advertisement for bakery,
1932
J. Mammen

OVER THE LEGACY OF THE PAST. ART AND INDUSTRY WERE ALLIED IN A CRUSADE TO CHANGE THE POPULAR PERCEPTION OF BUSINESS FROM STODGY TO VITAL. AND ART MODERNE EPITOMIZED WHAT THE INDUSTRIAL DESIGNER RAYMOND LOWEY REFERRED TO IN THE 1930s AS MAYA, "MOST ADVANCED YET ACCEPTABLE," AN ETHIC OF PURPOSEFULLY GRADUAL CHANGE. COMPARED TO THE EPITOME OF PROGRESSIVISM — THE COLD FUNCTIONALITY OF EUROPEAN MODERNIST MOVEMENTS SUCH AS THE BAUHAUS, PURISM, AND CONSTRUCTIVISM — ART MODERNE OFFERED A BALANCE OF ELEGANCE AND SIMPLICITY. IT WAS THEREFORE NOT A REVOLUTION IN DESIGN BUT AN EVOLUTION, FROM THE CURVILINEAR DECORATIVE STYLE THAT WAS ART NOUVEAU TO A RECTILINEAR ONE IN WHICH SHARP GEOMETRIES WERE THE HALLMARK OF MACHINE-BASED RATHER THAN ORGANIC AESTHETICS.

GIVEN HOLLAND'S SMALL SIZE AND POPULATION ITS CONTRIBUTION TO TWENTIETH-CENTURY AVANT-GARDE TYPOGRAPHY, PHOTOGRAPHY, AND GRAPHICS HAS BEEN DISPROPORTIONATELY PROFOUND. AFTER WORLD WAR I DUTCH DESIGNERS AND TYPOGRAPHERS AGGRESSIVELY CHALLENGED THE STATUS QUO BY TESTING THE LIMITS OF CONVENTIONAL VISUAL COMMUNICATION. TWO DISTINCT MOVEMENTS DEVELOPED, ONE ECLECTIC, THE OTHER ASCETIC. THE ECLECTIC STYLE WAS A DECORATIVE EXPRESSIONIST AESTHETIC ALTERNATELY REFERRED TO AS THE WENDINGEN STYLE, AFTER THE MAGAZINE OF THE SAME NAME, MEANING TURN OR UPHEAVAL, OR THE WIJDEVELD STYLE, SO NAMED FOR ITS INVENTOR, THE ARCHITECT, DESIGNER, AND EDITOR, H. TH. WIJDEVELD. IN 1918 HE FOUNDED WENDINGEN, THE JOURNAL OF A LOOSELY KNIT GROUP OF EXPRESSIONISTS KNOWN AS THE AMSTERDAM SCHOOL.

The second movement was the purist ethic of De Stijl (The Style), founded in 1917 by Theo van Doesburg who edited its journal of the same name. It was a reaction to the chaotic nature of art and design at the time, and an unprecedented rationalist methodology based on formalist experiments in architecture and visual communications that was destined to influence design throughout Europe.

The Wendingen style, writes Paolo Portoghesi in his book Wendingen, was known for "irrationality, perception through vision; De Stijl was known for rationality, perception through analysis" (Portoghesi and Fanelli, 1988). the Wendingen style was tied to a past era by its extravagances, which included complex and artful typographics. De Stijl was dedicated to a utopian future that rejected extravagance for economy. Despite these differences both schools did agree that an upheaval of values was necessary before society could be reoriented and reshaped.

Initially this proposition was presented by Holland's most influential architect, H. P. Berlage, who as early as 1903 began Holland's artistic renewal through the concept of "honesty in construction." In a critique of the nineteenth-century ornamental excesses that were still being affixed to architecture and graphics in the Netherlands he wrote, "The sham art has to be fought. We wish for reality again and not phantoms." Berlage advocated that design of all kinds should serve the community spiritually as well as functionally.

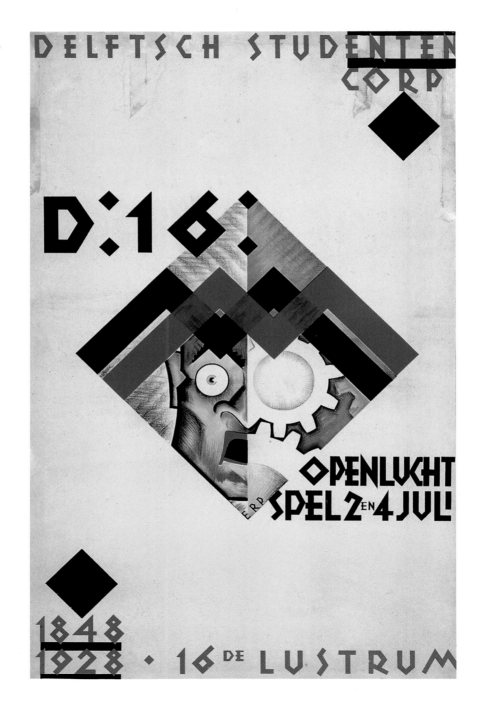

Although those who were influenced by Berlage shared this goal, they nevertheless developed his idea to extremes. "De Stijl exasperated the theme of formal simplification and rationality, and attained an absolute abstraction," wrote the German critic and architect Erich Mendelsohn in 1920. "The Amsterdam school exasperated the expressive search, the plastic characterization, the individualism, and adopted and developed many stylistic elements typical of the maestro [Berlage] but with a new accent that abandoned [him]" (quoted in Portoghesi and Fanelli, 1988).

In their attempt to alter popular perception by transforming traditional Dutch aesthetics, Wendingen artists introduced approaches that were often too artfully convoluted, while De Stijl was too rigidly mathematical. Wijdeveld was obsessed with the close unity of text and decoration in which legibility was not as important as graphic nuance or gesture. Geometric letter forms made from the lead slugs used in letterpress printing were run together without letter or word spacing. The effect was visually harmonious but sometimes illegible. Wijdeveld's typographic work received sporadic attention "mixed with irritation and jealousy. Irritation mostly for the presumed illegibility.... Jealousy for Wendingen's joyous aggressiveness," wrote Giovanni Fanelli in his essay "Wendingen as a Model of Typographic Art" (Portoghesi and Fanelli, 1988).

Van Doesburg and his early colleagues, among them the painter Piet Mondrian

AND ARCHITECTS J. J. P. OUD AND GERRIT RIETVELD, AIMED AT EXPRESSING THE UNIVERSAL PRINCIPLE OF TOTAL ABSTRACTION, OR WHAT H. L. C. JAFFÉ IN DE STIJL 1917-1931 CALLS "A RENDERING OF EXACT AND EQUILIBRIATED RELATIONS" THAT RESULTED IN COOL, ANALYTICAL DESIGN FORMS (JAFFÉ, 1986). DE STIJL WAS AGGRESSIVE IN ITS ORDERLINESS AND PRECISION. BY EMBRACING STRICT MODERNIST FORMALISM AND SOCIAL UTOPIANISM, DE STIJL WAS DEVOTED TO WHAT JAFFÉ CALLS THE "COLLECTIVE IMPERSONAL STYLE," A SEARCH FOR THE PLATONIC IDEAL.

CONTEMPORARY CRITICS, AND MANY CLIENTS, WERE ALIENATED BY BOTH SCHOOLS' REJECTION OF CONVENTIONAL AESTHETICS. YET SINCE THE WENDINGEN STYLE AND DE STIJL WERE PRACTICED FOR A DECADE AND A HALF, THEY EXERTED A PROFOUND STYLISTIC AND FORMAL INFLUENCE ON DUTCH COMMERCIAL GRAPHIC DESIGN. IN ADDITION TO HIS WORK ON WENDINGEN, WIJDEVELD PROMOTED HIS TYPOGRAPHY THROUGH DESIGNS FOR BOOKS AND CULTURAL POSTERS; THE STYLE WAS ADOPTED BY FOLLOWERS AND INNOVATORS WORKING IN SIMILAR MEDIA. VAN DOESBURG AND THE OTHER LOOSELY KNIT DE STIJL MEMBERS WHO PRACTICED GRAPHIC DESIGN ALSO MAINTAINED A VISUAL PRESENCE IN THE COMMERCIAL WORLD THROUGH ADVERTISING AND PACKAGES FOR MANUFACTURERS AND MERCHANTS. MOREOVER, VAN DOESBURG WAS INTERNATIONALLY RENOWNED FOR HIS RELATIONSHIP WITH OTHER MODERN MOVEMENTS INCLUDING CONSTRUCTIVISM, DADA, AND A RATHER CONTENTIOUS SOJOURN AT THE BAUHAUS. BY THE EARLY 1920S THE IDEAS PROMOTED BY BOTH SCHOOLS HAD INSPIRED OTHER DESIGNERS TO SERIOUSLY ADDRESS THE PAUCITY OF

SOPHISTICATED COMMERCIAL GRAPHIC DESIGN IN HOLLAND AS COMPARED TO OTHER INDUSTRIALIZED EUROPEAN NATIONS.

ALTHOUGH AN ACTIVE MOVEMENT OF DUTCH DESIGNERS REEVALUATED AND REVIVED CLASSIC TYPOGRAPHY, THEY WERE CONCERNED WITH REESTABLISHING THE TRADITIONS LOST DURING THE LATTER PART OF THE NINETEENTH CENTURY, WHEN THE GRAPHIC ARTS WERE AT THEIR NADIR. FOLLOWERS OF THE WENDINGEN STYLE AND DE STIJL WERE MORE INTERESTED IN CHANGING THOSE NICETIES. DESPITE THE IMPRESSIVE REFORMS OF THE TRADITIONALISTS, GRAPHIC DESIGN IN THE NETHERLANDS DURING THE 1920S WAS PUSHED IN THE DIRECTION OF TWO GRAPHIC STYLES: MODERN AND MODERNISTIC. THE FORMER WAS INFLUENCED BY EUROPE'S AVANT-GARDE, AND THE LATTER BY EUROPE'S DOMINANT COMMERCIAL STYLE.

BEFORE DISCUSSING DUTCH ART MODERNE, IT IS NECESSARY TO UNDERSTAND THE IMPACT OF AND RESPONSE TO THE MODERN MOVEMENT, FOR IT BOTH THREATENED AND REVIVED DUTCH COMMERCIAL CULTURE AND HAD BOTH A POSITIVE AND NEGATIVE INFLUENCE ON THE MODERNISTIC DESIGN. BEGINNING IN THE EARLY 1920S MODERN DESIGN MADE INROADS THROUGH THE EFFORTS OF SEMINAL DESIGNERS SUCH AS PIET ZWART, PAUL SCHUITEMA, GERARD KILJAN, WIM BRUSSE, HENNY CAHAN, AND DICK ELFFERS, WHO PRACTICED A VARIANT OF CONSTRUCTIVISM THAT INVOLVED ASYMMETRIC TYPOGRAPHY, PRIMARY COLORS, AND PHOTOMONTAGE. BY THE MID-1930S, OVER A DECADE AFTER RUSSIAN CONSTRUCTIVISM AND THE NEW TYPOGRAPHY (THE FUNCTIONAL TYPOGRAPHIC SYSTEM CODIFIED IN GERMANY BY JAN TSCHICOLD IN HIS BOOK NEUE TYPOGRAPHIE) HAD PEAKED AS VIABLE

DESIGN METHODOLOGIES, DUTCH CONSTRUCTIVISM AND TYPO-FOTO, AS THE MARRIAGE OF TYPE AND MONTAGE WAS CALLED, WERE ACCEPTED AS ADVERTISING CONVENTIONS BY VARIOUS CULTURAL, BUSINESS, AND GOVERNMENT INSTITUTIONS. THE PTT (THE DUTCH POSTAL, TELEPHONE, AND TELEGRAPH COMPANY) BLAZED A TRAIL FOR PROGRESSIVE DESIGN BY COMMISSIONING PIET ZWART, AMONG OTHER MODERNS, TO CREATE MATERIALS THAT ARE PARADIGMS OF THE ERA'S FUNCTIONAL AESTHETIC. PRAISE WAS ALSO HEARD IN THE DESIGN INDUSTRY FOR NEW, RATIONALIST APPROACHES, AS WERE ARGUMENTS THAT EMPHASIZED THE CREATION OF NEW STANDARDS OF BEAUTY AS AN ALTERNATIVE TO OUTDATED FORMS. AND YET CRITICISM FOR THESE APPROACHES CONTINUED.

ANTIQUATED APPROACHES HAD DOMINATED DUTCH GRAPHICS EVEN AS EUROPEAN DESIGN WAS CHANGING BY LEAPS AND BOUNDS. PRIOR TO WORLD WAR I THE NETHERLANDS WAS NOT KNOWN FOR A HIGH LEVEL OF GRAPHIC OR ADVERTISING DESIGN. DESPITE THE ANOMALY OF A FEW BEAUTIFUL POSTERS IN THE POSTIMPRESSIONIST, SYMBOLIST, MAGIC REALIST, AND EXPRESSIONIST STYLES, HOLLAND'S COMMERCIAL GRAPHICS FAR FROM EQUALED THE INNOVATIVE POSTERS, LETTERING, AND TYPOGRAPHY OF FIN-DE-SIECLE FRANCE, GERMANY, ENGLAND, AND ITALY. LEADERS OF INDUSTRY AND GOVERNMENT IN THOSE CONSUMER NATIONS REALIZED THE BENEFITS OF JOINING ART WITH INDUSTRY, BUT THEIR DUTCH COUNTERPARTS RESISTED ENTRUSTING ARTISTS WITH MATTERS OF COMMERCE. WHILE ARCHITECTURE WAS EXPERIENCING A RENAISSANCE OF SORTS, GRAPHICS WERE KEPT LOCKED IN A TIME WARP. ADVERTISING AGENCIES EXISTED, BUT MOST ENCOURAGED MEDIOC-

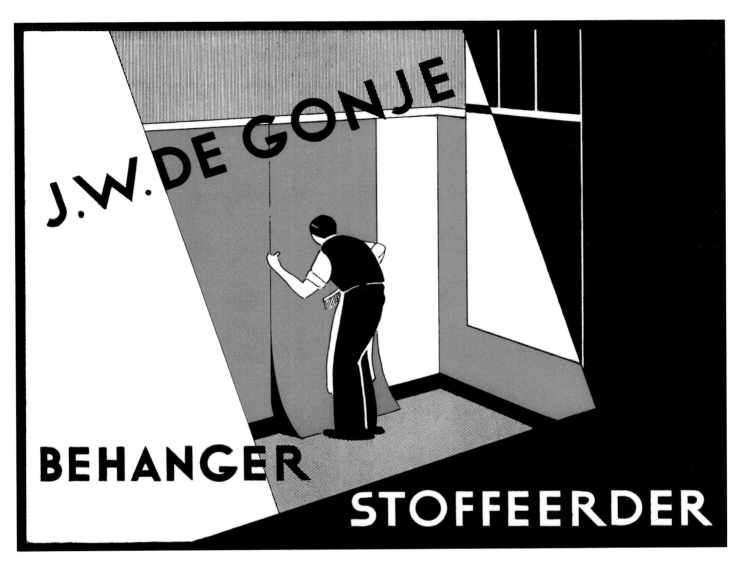

J.W. DE GONJE
Wallpaper Manufacturer's Neon Sign, 1935
Roel Knobbe

RITY AS ADVERTISERS RAILED AGAINST THE "ARTISTIC DESIGNER" FOR BEING AN AESTHETE WHO DID NOT UNDERSTAND THE CONVENTIONS OF MARKETING.

YET THE ADVERTISER'S NEGATIVE ATTITUDE AND THE RESULTING AESTHETIC STAGNATION CANNOT BE BLAMED ENTIRELY ON AN IRRATIONAL MISTRUST OF AESTHETES, FOR THE DEEPLY ROOTED CALVINISM INSTILLED EVEN IN NON-PROTESTANTS INSPIRED A FUNDAMENTAL DISTASTE FOR MARKETING OF ANY KIND. ADVERTISING WAS CONSIDERED A SINFUL MEDIUM. HOLLAND'S LATE DEVELOPMENT OF AN INDIGENOUS VISUAL CULTURE CAN THEREFORE BE ATTRIBUTED TO THE BELIEF THAT ADVERTISING WAS A NECESSARY EVIL, AND THUS UNENTHUSIASTICALLY SUPPORTED BY THE VERY BUSINESS PEOPLE WHO NEEDED IT MOST. AS DICK DOOIJES AND PIETER BRATTINGA EXPLAIN, "IN LEADING CIRCLES IN THE NETHERLANDS MONEY HAS A DIRTY NAME AND IS NOT TO BE TALKED ABOUT. IT WAS THEREFORE VERY HARD FOR THESE PEOPLE TO APPRECIATE THE ARTISTS WHO WERE WILLING TO PUT THEIR 'GOD-GIVEN' TALENTS AT THE DISPOSAL OF MONEYMAKERS" (DOOIJES AND BRATTINGA, 1968).

THE PLAN OF HOLLAND'S CITIES ALSO CONTRIBUTED TO THE LATE START OF DUTCH GRAPHIC DESIGN, PARTICULARLY THE POSTER. UNLIKE MOST EUROPEAN CAPITALS, WHERE POSTERS WERE HUNG ALONG THE GRAND BOULEVARDS AND WIDE AVENUES, DUTCH CITIES ARE WEBS OF SMALL WINDING STREETS. THE DUTCH POSTER WAS THEREFORE NOT DESIGNED FOR LONG-DISTANCE VIEWING, WITH STARK COLORS AND SIMPLE IMAGES, BUT WAS MORE TYPE HEAVY, FOR SHORT-DISTANCE READING.

ALTHOUGH IN THE LATE NINETEENTH CENTURY SOME HISTORICALLY SIGNIFICANT

ATTEMPTS WERE MADE TO ELEVATE GRAPHICS BY ADOPTING THE TENETS OF ART NOUVEAU (NIEUWE KUNST IN DUTCH), THE RESULTS DID NOT COMPARE WITH, OR AT BEST MIMICKED, FRENCH AND GERMAN APPROACHES. NOT UNTIL AFTER WORLD WAR I DID A DISTINCTIVE NATIONAL STYLE BEGIN TO SHOW ITSELF IN POSTERS BY PIONEERS SUCH AS R. N. ROLAND HOLST, C. A. LION CACHET, ALBERT PIETER HAHN, SR., JAN C. B. SLUYTERS, AND JACOB (JAC.) JONGERT. THE UNIQUE MARRIAGE OF RAW EXPRESSIONISM AND CARNIVAL-LIKE ORNAMENTALISM NOT ONLY REFLECTED THE STYLISTIC AND CONCEPTUAL FLUX WITHIN CONTEMPORARY ART BUT SYMBOLIZED THE CATHARTIC EFFECTS OF THE WAR.

THE HORRORS OF WORLD WAR I INEXORABLY ALTERED BASIC HUMAN VALUES AND USHERED IN NEW VISUAL EXPRESSIONS. WHILE IN NEIGHBORING EUROPEAN COUNTRIES MONARCHIES FELL AND INSTITUTIONS CRUMBLED, IN HOLLAND WORKERS WERE EMPOWERED THROUGH THE SOCIAL DEMOCRATIC WORKERS' PARTY. GOODS AND MONEY WERE REDISTRIBUTED WHEN A PRIVATIZED SYSTEM WAS TRANSFORMED INTO A MORE DEMOCRATIC ONE. TURMOIL IN ALL SEGMENTS OF SOCIETY WAS IMPETUS ENOUGH FOR ARTISTS TO TAKE MORE CRITICAL ROLES IN POLITICS AND CULTURE. THE WENDINGEN STYLE AND DE STIJL CERTAINLY WERE SPUN OUT OF THIS VORTEX OF CHANGE. ARTISTS ACTIVELY INVOLVED THEMSELVES BY DESIGNING POLITICAL PROPAGANDA IN AN ATTEMPT TO FIND NEW AVENUES FOR THEIR GRAPHIC VOCABULARIES.

TRADE ORGANIZATIONS WERE FOUNDED TO ADVOCATE GREATER PARTICIPATION OF ARTISTS IN DUTCH SOCIETY. AND AS THE NEW PROFESSION OF ARTIST-DESIGNER GAINED A

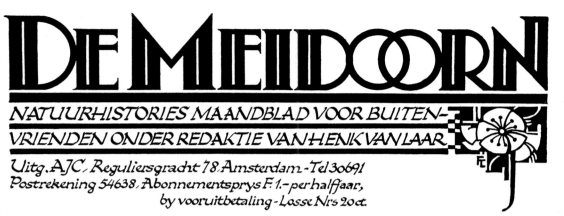

DE MEIDOORN
Masthead for nature magazine,
1931

FOOTHOLD IN POSTWAR HOLLAND, PRESSURE WAS PUT ON THE GOVERNMENT AND INDUSTRY TO USE GOOD DESIGN. YET THE DEFINITION OF WHAT WAS GOOD (OR APPROPRIATE) DESIGN BECAME A POINT OF CONTENTION. PROGRESSIVE ARTISTS AND THEIR PATRONS STRUGGLED TO CREATE STANDARDS BASED ON CONTEMPORARY VALUES, SUCH AS ELEMENTARISM AND FUNCTIONALISM. NEVERTHELESS, A COUNTERFORCE FROM ADVERTISING AND BUSINESS ARGUED AGAINST THE NEW FORMS AS ABERRATIONS.

SOMEWHERE BETWEEN THE OLD TRADITION OF A CRAFTSMAN-ARTIST LOYAL TO PAST VERITIES AND THE NEW IDEA OF AN ARTIST-ENGINEER DEVOTED TO THE MOST ELEMENTAL METHODS OF VISUAL COMMUNICATION IS FOUND THE PRACTITIONER OF ART MODERNE, WHO PROFFERED A COMPROMISE AESTHETIC THAT BALANCED DECORATIVE ART WITH MODERN THEORY. BUT ART MODERNE WAS NOT INVENTED IN HOLLAND, ART MODERNE WAS IMPORTED FROM FRANCE AND GERMANY. THE FRENCH MASTER A. M. CASSANDRE PROVIDED THE MOLD FROM WHICH MANY DUTCH EXAMPLES DERIVED. THE TRADE MAGAZINES, MOST NOTABLY DE

RECLAME (ADVERTISING), WHICH HAD GIVEN PERFUNCTORY COVERAGE TO THE NEW TYPOGRAPHY, EXTOLLED THE VIRTUES OF ART MODERNE THROUGH COVERS AND ARTICLES THAT EXHIBITED THE BEST EUROPEAN AND DUTCH STYLISTS.

AS ELSEWHERE IN EUROPE, ART MODERNE IN HOLLAND WAS EXUBERANT, THOUGH POLITICALLY NEUTRAL. WHILE THE NEW TYPOGRAPHY WAS SYMBOLIC OF SOCIALIST, COMMUNIST, OR UTOPIAN IDEALS (EVEN AS APPLIED TO CERTAIN MAINSTREAM INDUSTRIES), ART MODERNE REPRESENTED THE FASHION AND TREND OF THE MOMENT. AS A UNIVERSAL STYLE IT WAS INOFFENSIVE IN THE MASS MARKETPLACE, WHETHER PROMOTING PRODUCTS OR IDEAS, AND COULD BE USED EFFECTIVELY FOR A VARIETY OF PURPOSES.

DESPITE THIS SYMBOLIC NEUTRALITY, ART MODERNE DID DEVELOP A DISTINCT IDIOM INCORPORATING TYPOGRAPHIC CHARACTERISTICS OF THE WENDINGEN STYLE, DE STIJL, AND THE NEW TYPOGRAPHY. ART MODERNE, ALTHOUGH DOWNPLAYED IN ACCOUNTS OF DUTCH GRAPHIC DESIGN, EVOLVED FROM A SYNTHESIS OF TRADITIONAL AND RADICAL FORMS INTO A VIABLE COMMERCIAL LANGUAGE THAT ENJOYED POPULARITY, PEAKED IN THE 1930S, AND ALMOST COMPLETELY DISAPPEARED DURING WORLD WAR II WHEN THE HARDSHIPS OF OCCUPATION ELIMINATED THE NEED FOR VIGOROUS COMMERCIAL ADVERTISING. AFTER THE WAR, ART MODERNE WAS PLAYED OUT IN HOLLAND, REPLACED BY BOTH NONDESCRIPT FORMS AND THE SWISS-INSPIRED INTERNATIONAL STYLE. ALTHOUGH ART MODERNE IS OBSOLETE TODAY, GONE WITHOUT A TRACE FROM CURRENT GRAPHIC DESIGN IN THE NETHERLANDS, IT WAS THE MEANS BY WHICH THE DUTCH AVANT-GARDE WAS ASSIMILATED AND DEMYSTIFIED.

For centuries the Netherlands has been a haven of free speech. During the eighteenth century, Dutch artists created reams of acerbic social and satiric prints, which were freely distributed and served as archetypes for other European artists. By the **POLITICS** early twentieth century a multitude of posters were created to promote the candidates and ideals of Holland's disproportionately numerous political parties. Comprising the political alphabet soup were, among others, RKSP (Rooms-Katholieke Staatspartij), CPN (Communist Party of the Netherlands), and SDAP (Social Democratic Workers' Party). The last, the leading Dutch labor advocate, was the most prolific producer of posters, and in the 1930s art moderne was the principal style of persuasion. Portraying the worker in stylized monumental poses helped underscore the myth of the noble proletariat that SDAP and other labor groups hoped to propagate. By the late 1920s and 1930s, when the worldwide economic depression struck the Netherlands, these graphic representations helped uplift the suffering worker's image. Yet art moderne was not monopolized by the SDAP — its opponents also effectively used the style to capture hearts and minds.

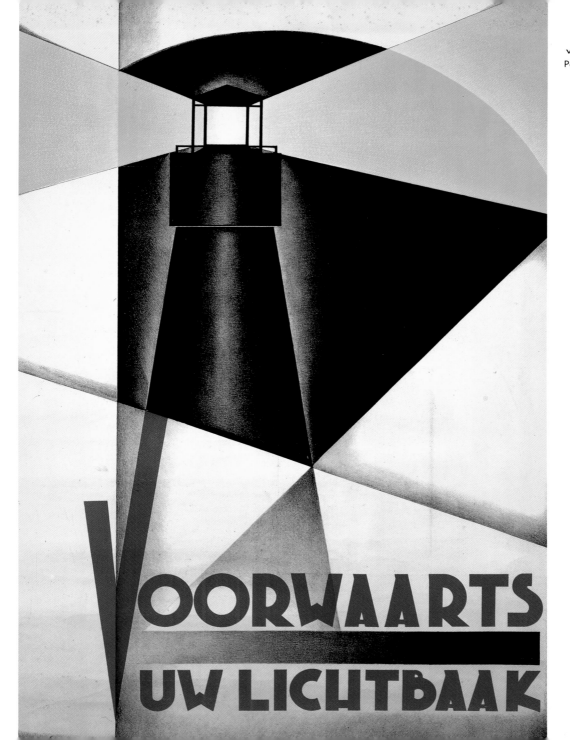

V O O R W A A R T S
Political poster, 1927
A. J. F. Küpper

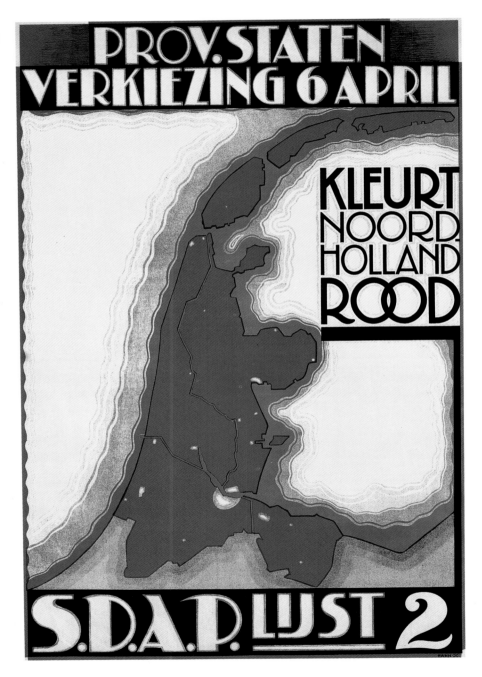

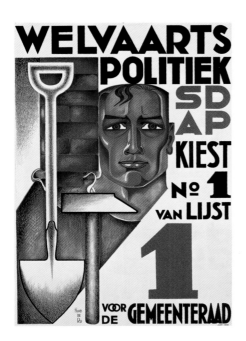

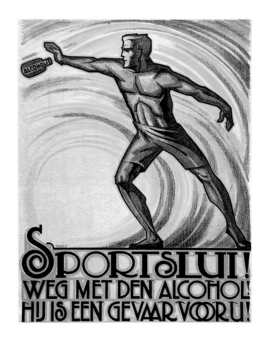

WELVAARTS POLITIEK SDAP
Election poster, 1935
Huib de Ru

SPORTSLUI!
Anti-alcohol poster, 1935
Albert Pieter Hahn, Jr.

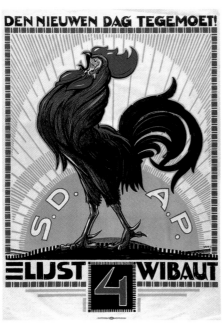

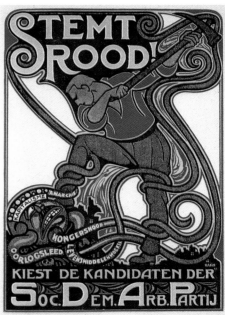

SDAP LIJST 4 WIBAUT
Election poster, c. 1927
Albert Pieter Hahn, Jr.

STEMT ROOD!
SDAP election poster, 1919
Albert Pieter Hahn, Sr.

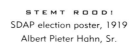

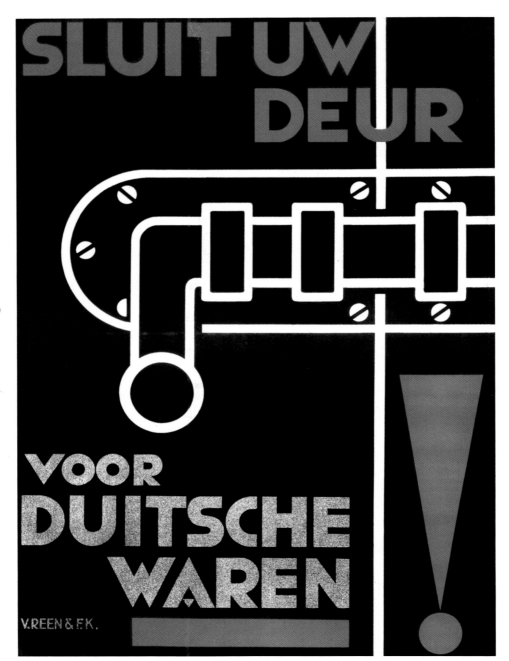

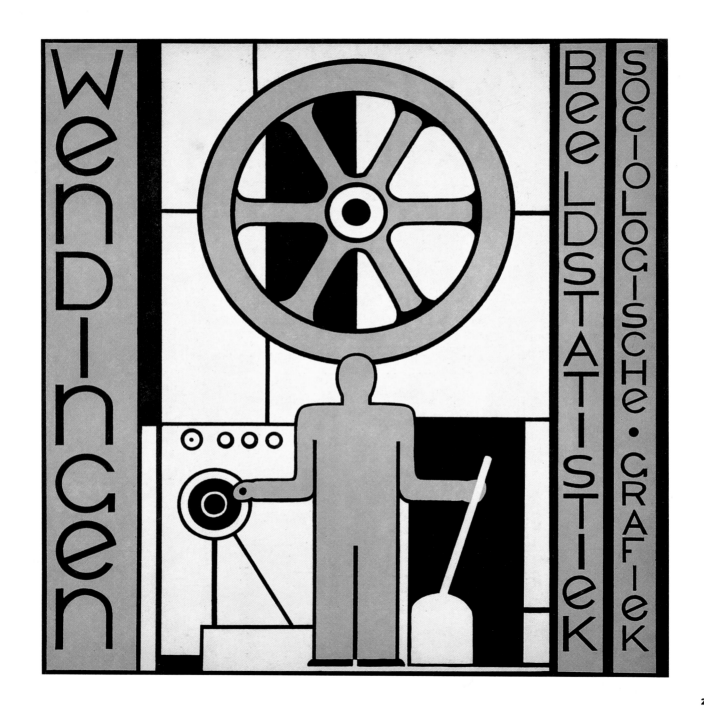

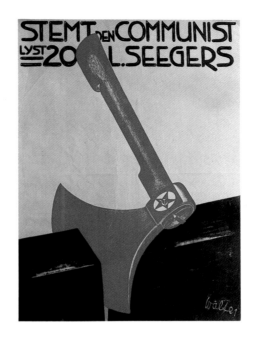

STEMT DEN COMMUNIST
Election poster, c. 1930
J. Walter

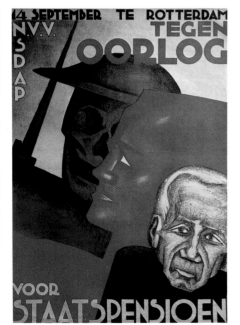

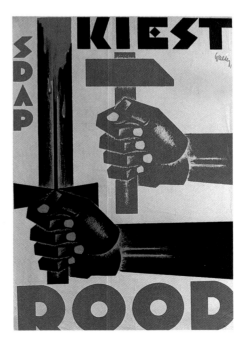

TEGEN OORLOG
Antiwar/pension poster, 1930
Meijer Bleekrode

KIEST ROOD
Election poster, 1929
J. Walter

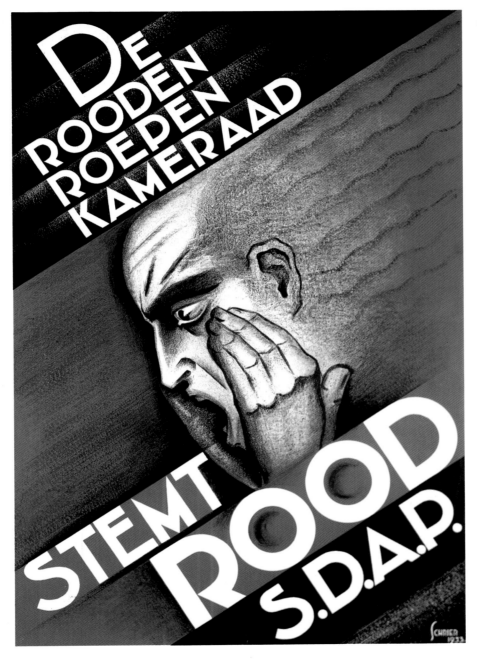

STEMT ROOD
Election poster, 1933
Schrier

KATHOLIEKEN
Election poster, 1929
Frans Bosen

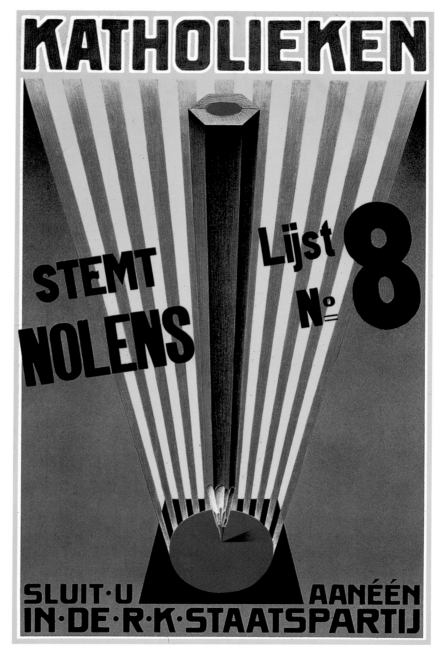

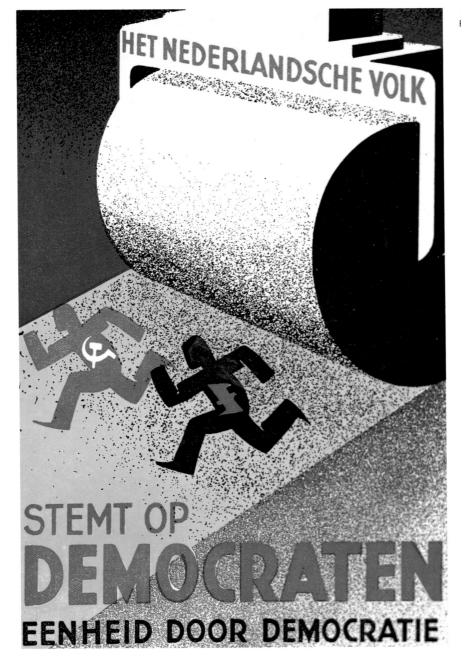

SINCE BUSINESS AND INDUSTRY WERE INITIALLY RETICENT TO ACCEPT AVANT-GARDE DESIGN,

THE CULTURAL ARENA BECAME THE PROVING GROUND FOR CHANGE IN GRAPHIC ARTS. SOME

OF THE MOST SIGNIFICANT TYPOGRAPHIC EXPERIMENTS WERE DONE AS EXHIBITION

ANNOUNCEMENTS AND FOR **CULTURE** BOOK COVERS. ALTHOUGH

WENDINGEN OCCASIONALLY EXPRESSED POLITICAL IDEAS, IT WAS PRIMARILY A CULTURAL

JOURNAL WHOSE IMPACT WAS ON THE ARTS COMMUNITY AND ITS SCHOOLS. THE JOURNAL

WAS A SHOWCASE FOR THE AESTHETICS THAT CAME TO UNDERSCORE THE ACTIVE CULTURAL

LIFE OF HOLLAND. THE DISTINCTIVE GEOMETRIC LABYRINTH USED BY THE WENDINGEN STYL-

ISTS IN THEIR GRAPHICS BECAME A VIRTUAL EMBLEM OF EARLY POSTWAR DUTCH DESIGN.

IN ADULTERATED FORM, THE WENDINGEN STYLE'S RECTILINEAR, DECORATIVE MANNERISMS

WERE ADOPTED AND PROMOTED THROUGH ADVERTISING TRADE MAGAZINES, WHICH EXPLOITED

THE COMMERCIAL ADVANTAGES OF THIS RADICAL STYLE. THE MOST POPULAR OF THESE MAGA-

ZINES, DE RECLAME, WAS MORE LIKELY TO FEATURE DECORATIVE STYLES OVER FUNCTIONAL

MODERN APPROACHES, AND IT GAVE ONLY A MODICUM OF ATTENTION TO PURIST AESTHETICS.

THE COVERS OF THIS INFLUENTIAL PERIODICAL, WHICH WERE USUALLY ADORNED WITH MOD-

ERNISTIC IMAGES, SERVED AS MODELS FOR PRINT SHOPS, ADVERTISING AGENCIES, AND THE

MAJORITY OF ONTWORPERS (COMMERCIAL DESIGNERS).

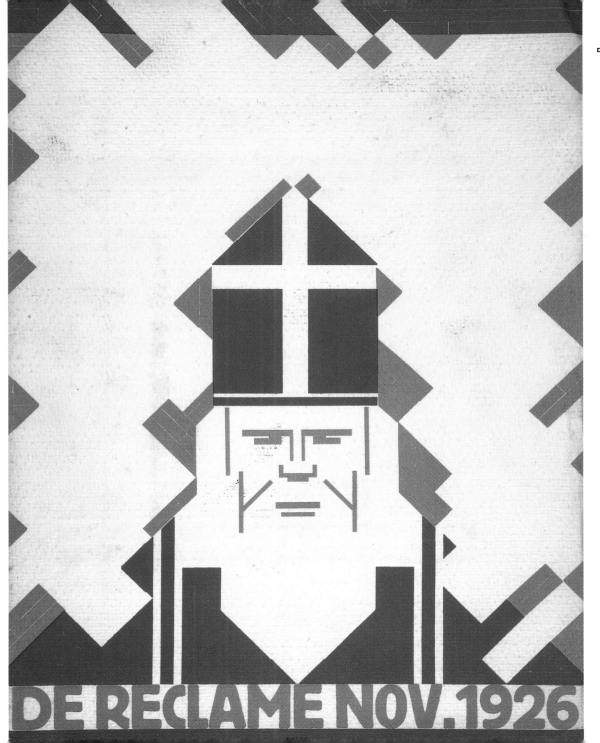

DE RECLAME
Advertising
magazine cover,
1926

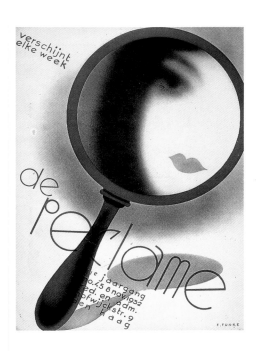

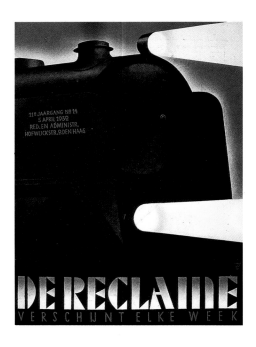

DE RECLAME
Advertising magazine cover, 1932
F. Funke

DE RECLAME
Advertising magazine cover, 1932
J.A.W. von Stein

DE RECLAME
Advertising magazine cover, 1930
Mander

DE RECLAME
Advertising magazine cover, 1932
F. Funke

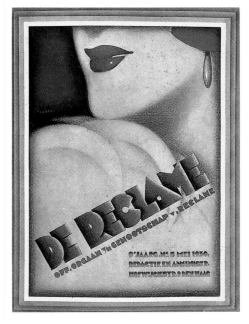

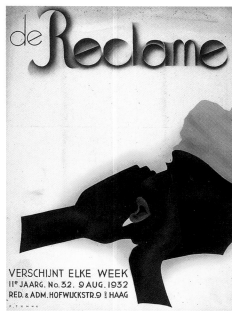

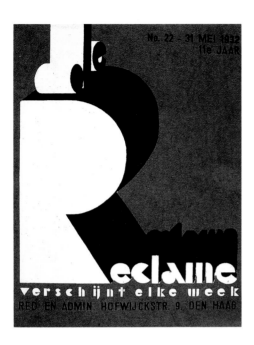

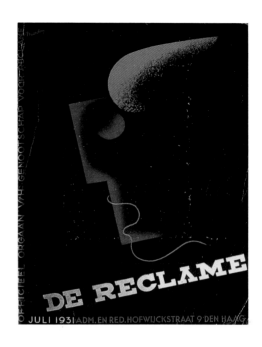

DE RECLAME
Advertising magazine cover, 1932

DE RECLAME
Advertising magazine cover, 1931
Marton

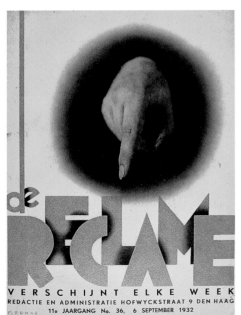

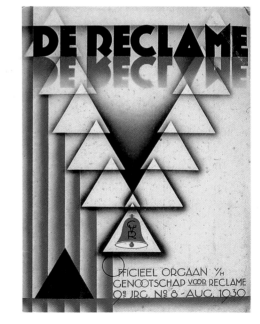

DE RECLAME
Advertising magazine cover, 1932
F. Funke

DE RECLAME
Advertising magazine cover, 1930

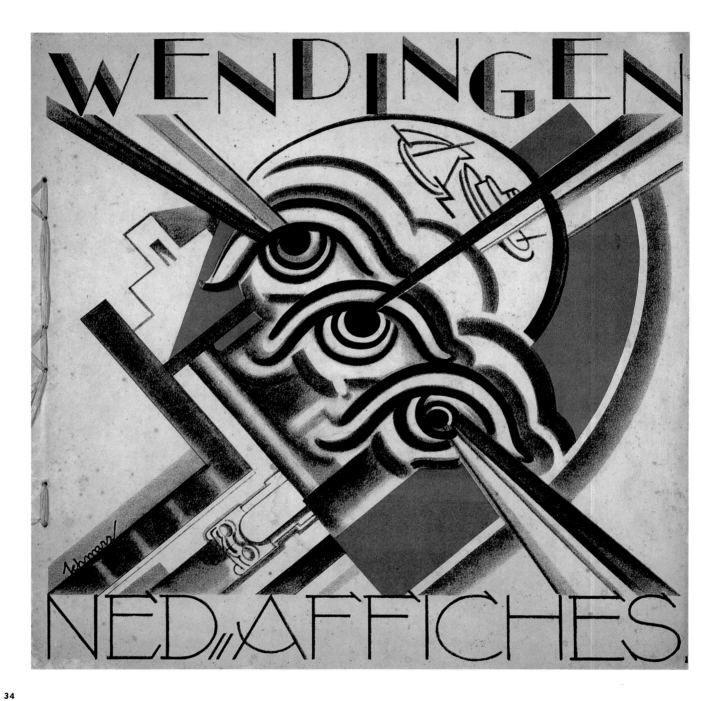

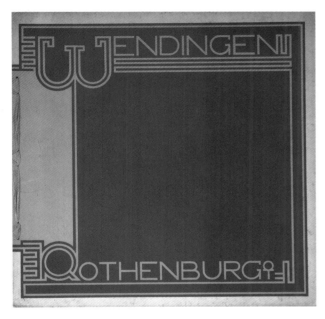

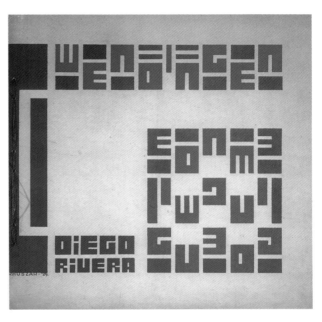

WENDINGEN/QOTHENBURG
Magazine cover, 1930
A.P. Smits

WENDINGEN/DIEGO RIVERA
Magazine cover, 1929
Vilmos Huszár

WENDINGEN/NED AFFICHES
Magazine cover, 1931
Samuel Schwarz

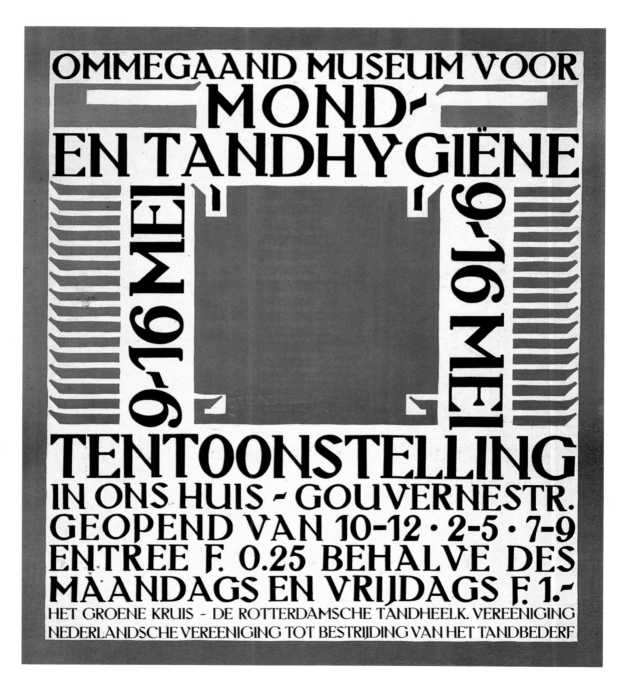

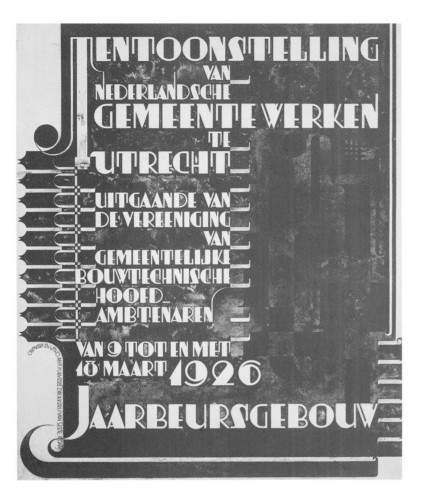

VAN NEDERLANDSCHE
GEMEENTE WERKEN
Exhibition poster, 1926
Antoon Kurvers

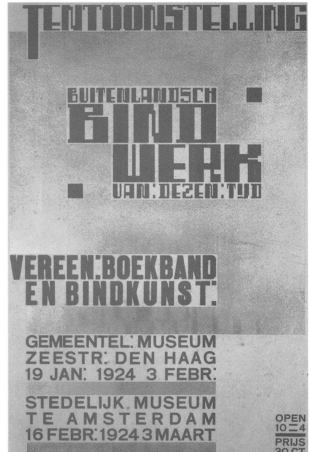

BUITENLANDSCH BIND WERK
VAN DEZEN TIJD
Exhibition poster, 1924
H. Th. Wijdeveld

MOND-EN TANDHYGIËNE
Exhibition poster, 1925

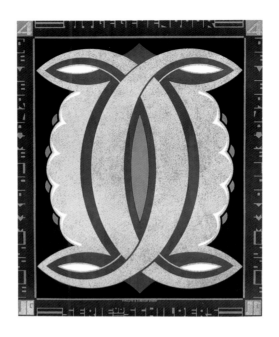

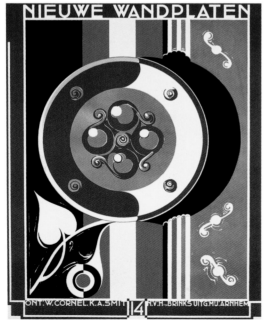

UITGEGEVENDOOR
DE VERZAMELCONNISSIE
Poster, 1922
Jaap Gidding

NIEUWE WANDPLATEN
Poster, c. 1928
K. A. Smit and W. Cornelis

UITGEGEVENDOOR
DE VERZAMELCONNISSIE
Poster, 1922
Jaap Gidding

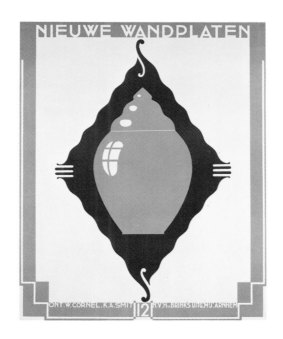

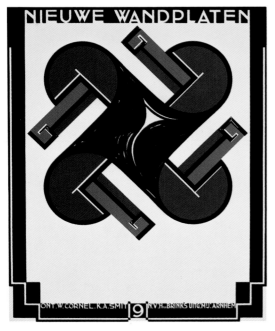

NIEUWE WANDPLATEN
Poster, c.1928
K.A. Smit and W. Cornelis

NIEUWE WANDPLATEN
Poster, c.1928
K.A. Smit and W. Cornelis

NIEUWE WANDPLATEN
Poster, c.1928
K.A. Smit and W. Cornelis

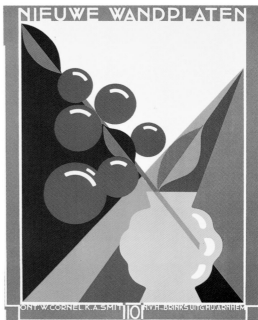

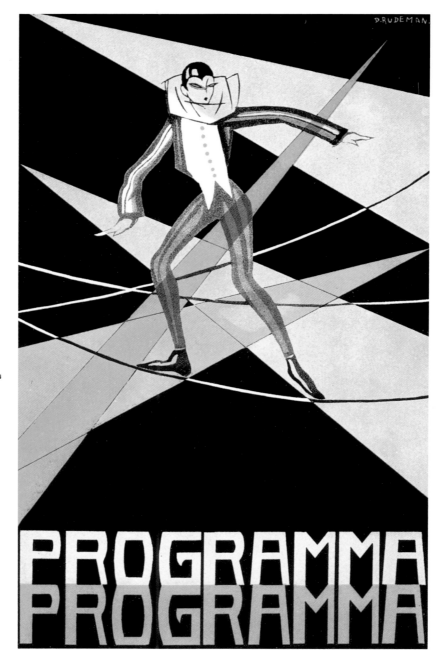

PROGRAMMA
Circus advertisement, 1927
D. Rudeman

(Opposite)
EFFICIENCY
TENTOONSTELLING
Exhibition poster, 1932

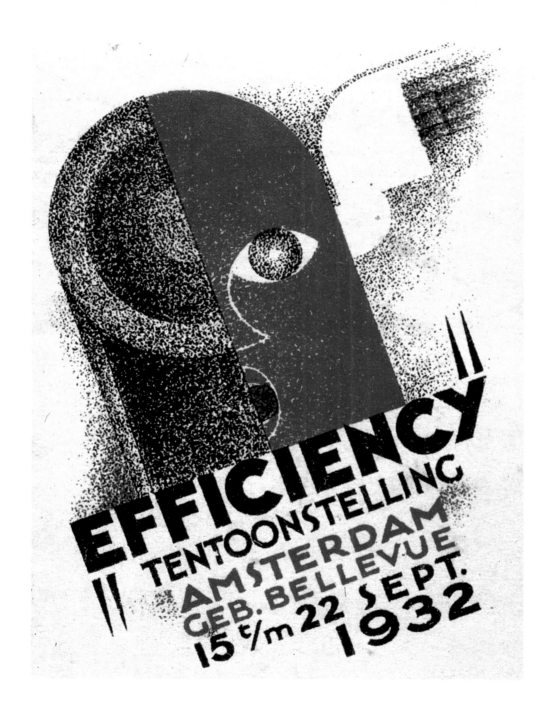

EFFICIENCY
TENTOONSTELLING
AMSTERDAM
GEB. BELLEVUE
15 t/m 22 SEPT.
1932

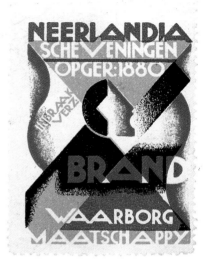

NEERLANDIA
Poster stamp, c. 1934

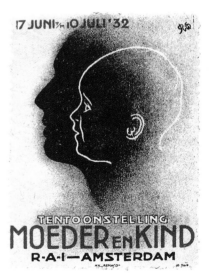

MOEDER EN KIND
Poster stamp, 1932

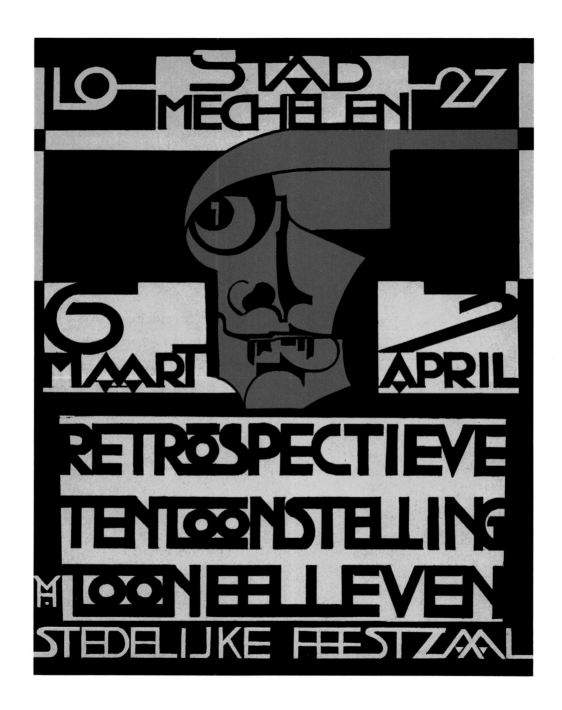

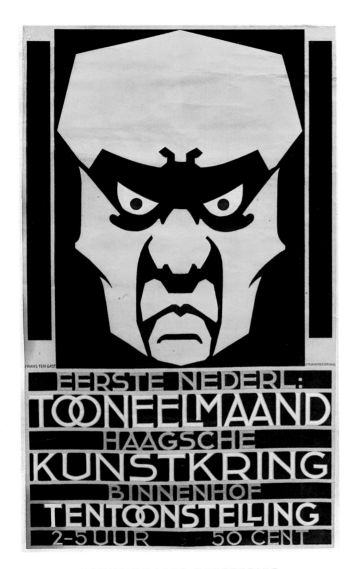

TOONEELMAAND KUNSTKRING
Exhibition poster, c. 1920
Frans ter Gast

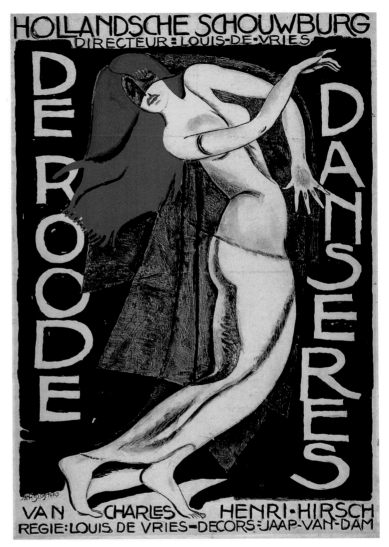

DE ROODE DANSERES
Dance poster, 1922
Jan C. B. Sluyters

STAD MECHELEN RETROSPECTIEVE
TENTOONSTELLING
Exhibition poster, 1927
Jan Kuper

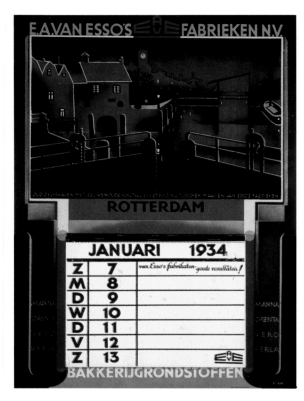

E. A. VAN ESSO'S
FABRIEKEN N.V.
Calendar, 1934

1916
Calendar, 1916
Van H. Kannegieter

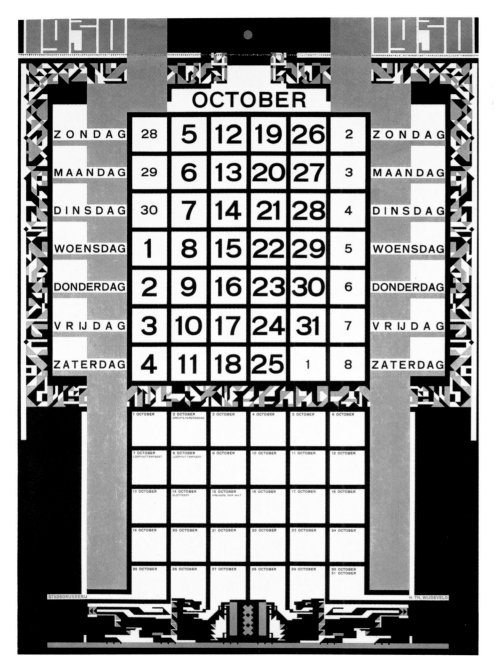

ULTRAPHOON HUIS
Record jackets, c. 1922
Chris Lebeau

OCTOBER, 1930
Calendar, 1930
H. Th. Wijdeveld

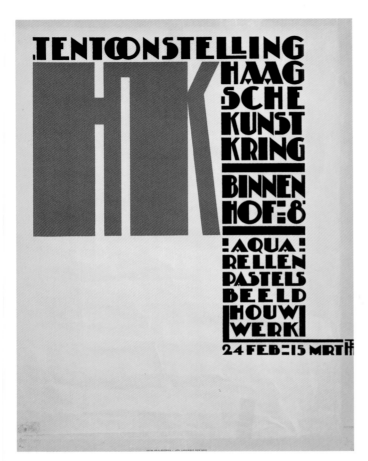

TENTOONSTELLING
Exhibition poster, 1925
P. A. H. Hofman

HAACISCHE KUNSTKRING
Exhibition poster, 1932
P. A. H. Hofman

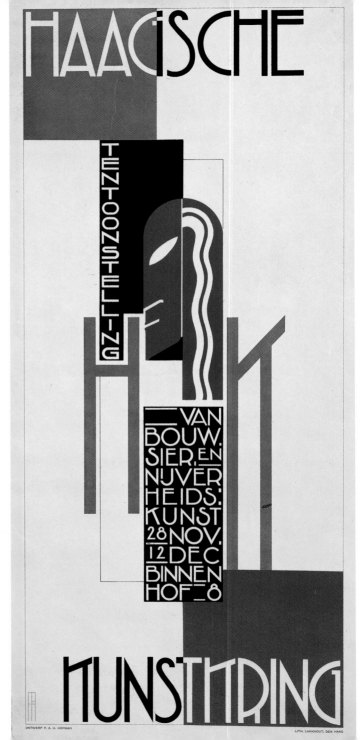

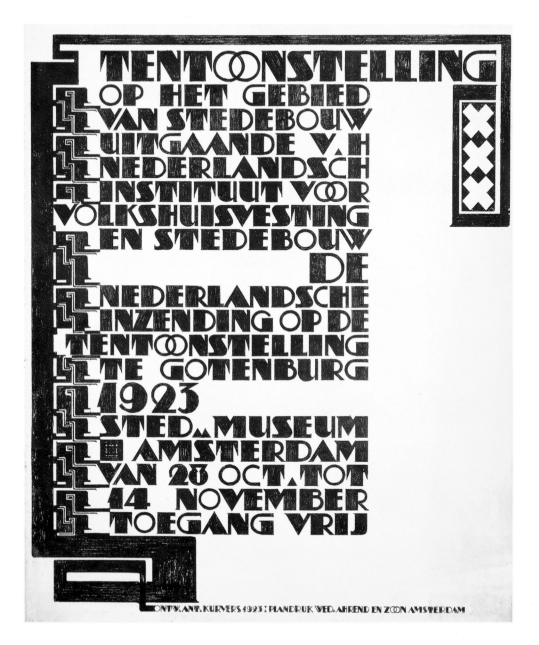

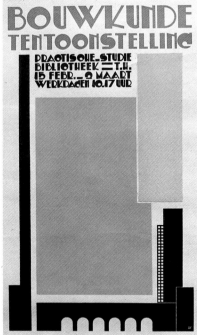

BOUWKUNDE
TENTOONSTELLING
Exhibition poster, c. 1930
H.K.

TENTOONSTELLING
Exhibition poster, 1923
Antoon Kurvers

DUE TO THE COUNTRY'S DEEP-SEATED WORK-ETHIC AND FREE-MARKET LIBERALISM, MANY INTERNATIONAL CORPORATIONS WERE BASED IN HOLLAND BY THE TWENTIETH CENTURY. VANK (ASSOCIATION OF ARTISTS OF CRAFTS AND INDUSTRY), FOUNDED IN 1904, PROMOTED THE DEVELOPMENT **INDUSTRY** OF ARTS AND CRAFTS IN THE INDUSTRIAL SECTOR THROUGH PUBLICATIONS, EXHIBITIONS, AND DEMONSTRATIONS OF DESIGN'S BENEFITS. DURING THE LATE 1920s HOLLAND'S MOST PROGRESSIVE DESIGNERS, SUCH AS PIET ZWART AND PAUL SCHUITEMA, APPLIED CONSTRUCTIVIST AND RATIONALIST TYPOGRAPHY FOR CERTAIN FORWARD-LOOKING INDUSTRIAL CLIENTS, BUT THE DOMINANT GRAPHIC STYLE WAS ART MODERNE. DESPITE THE COMPLAINT OF SOME DESIGN CRITICS THAT ART MODERNE WAS A MEANINGLESS CONGLOMERATION OF PRINTER'S ORNAMENTS, IT SERVED MANY MASTERS WELL. THE INDUSTRIAL GIANT, PHILIPS, PRODUCER OF RADIOS, LIGHTING, AND ELECTRONIC PARTS, BECAME ONE OF THE MOST VISIBLE MANUFACTURERS IN HOLLAND, AND ITS PRODUCTS GAINED A COMPETITIVE EDGE THROUGH THE COMPANY'S AMBITIOUS PROGRAM OF MODERN ADVERTISING AND PACKAGING. THE ANNUAL JAARBEURS (INDUSTRIAL FAIR) IN UTRECHT ALSO ADOPTED ART MODERNE, IN STRIKING MODERNISTIC POSTERS THAT AT ONCE SYMBOLIZED THE FUTURE AND MONUMENTALIZED INDUSTRY.

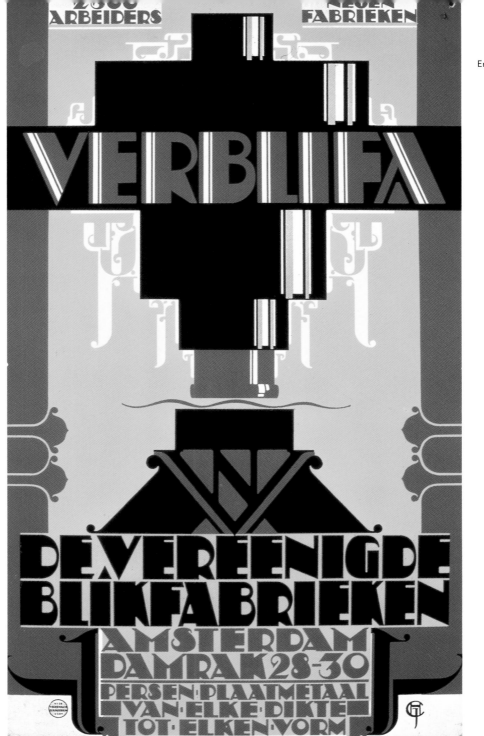

VERBLIFA
Enamel sign, 1920
C.J. v.d. Hoef

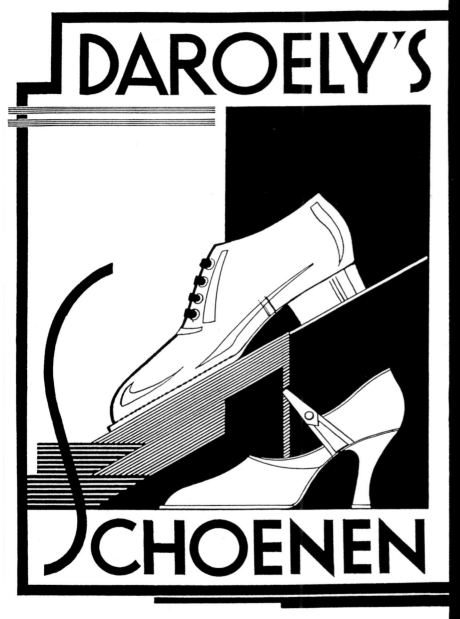

DAROELY'S SCHOENEN
Shoe advertisement, 1932
J. P. van Wees

ECONOMIE
Rubber sole trademark, 1931

NIMCO
Shoe trademark, 1935

DUBBELGANGER
Shoe trademark, 1931

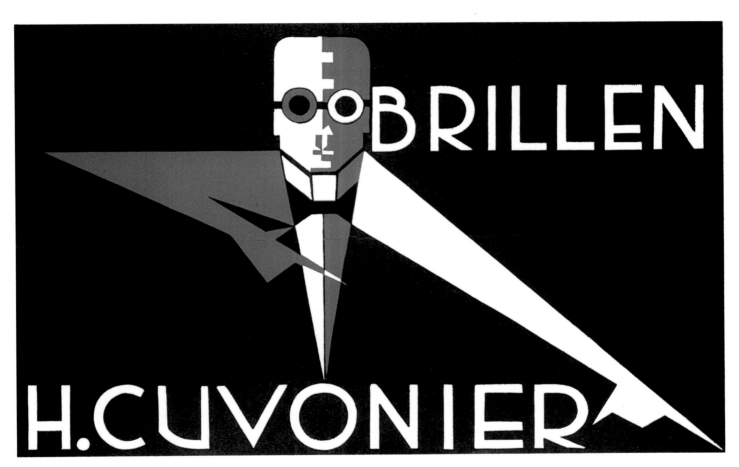

H. CUVONIER
Optician's advertisement, 1933
C. J. Snoeijerbosch

STOFFEN

BABY-SANA
Haberdashery trademark, 1930

NAJADE
Woolen knits trademark, 1933

SERCO

SERCO
Hat trademark, 1929

BARA
Fabric trademark, 1929

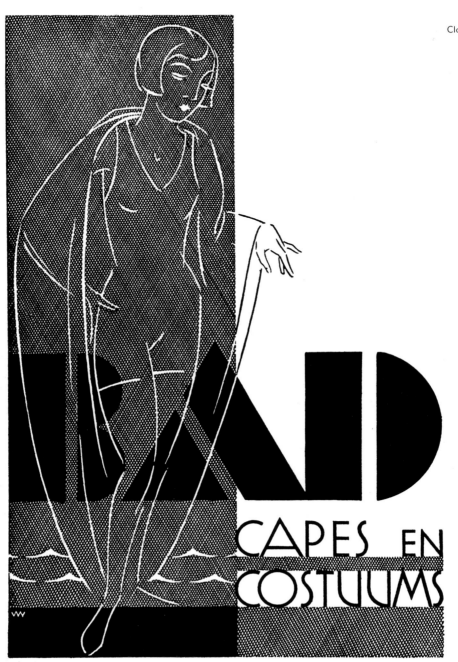

B A D
Clothier's advertisement,
1933
Jan P. van Wees

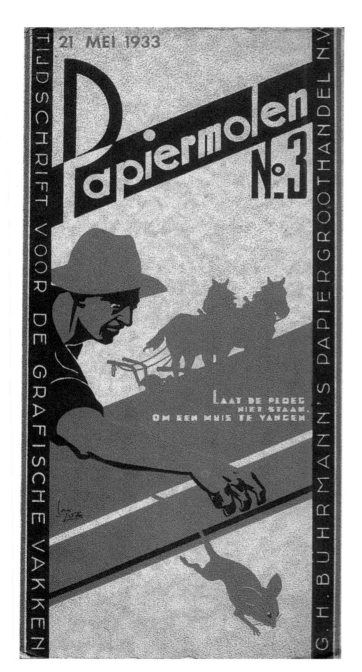

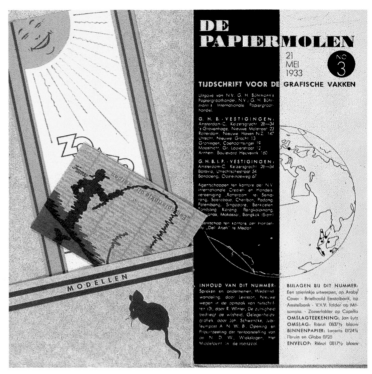

DE PAPIERMOLEN
Paper company promotions,
1933

DE PAPIERMOLEN
Catalog cover, 1933

JAARBEURS
UTRECHT 9-18
SEPTEMBER
1941
Exposition poster, 1941
Steen

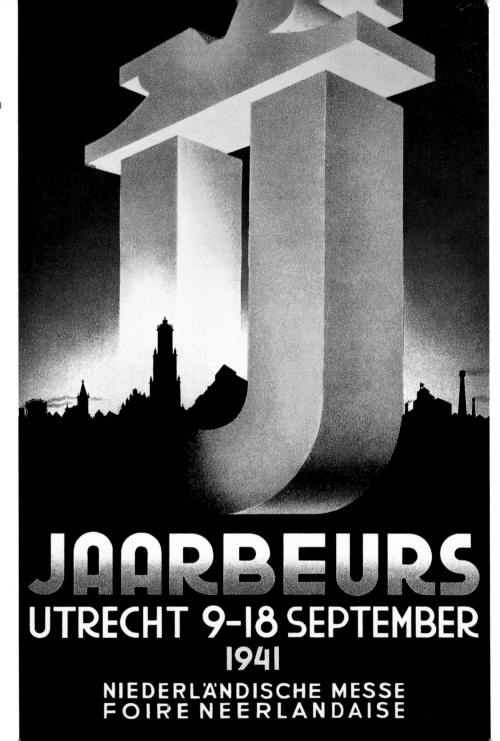

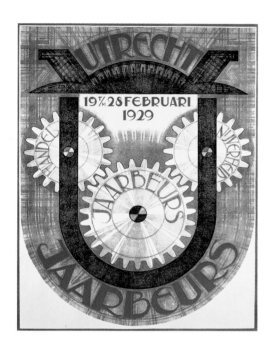

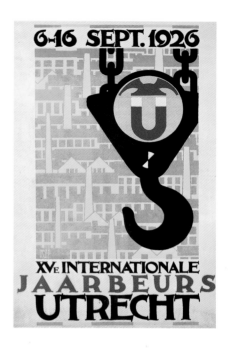

JAARBEURS UTRECHT
Exposition poster, 1929
Erna van Osselen

JAARBEURS UTRECHT
Exposition poster, 1926
Louis Kalff

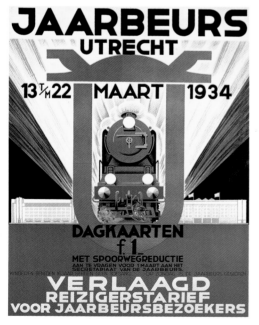

JAARBEURS UTRECHT
Exposition poster, 1934

JAARBEURS UTRECHT
Exposition poster, 1934

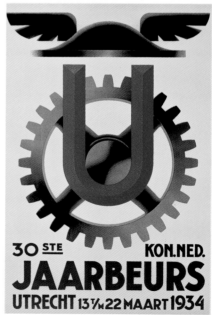

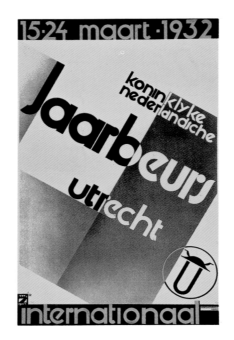

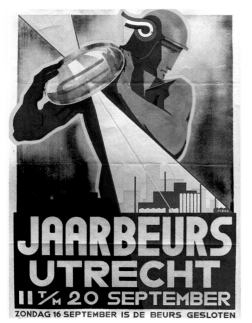

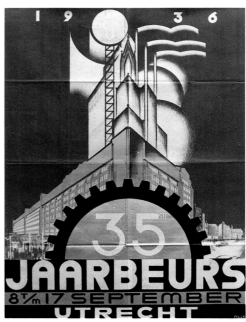

JAARBEURS UTRECHT
Exposition poster, 1932
Zeguers

JAARBEURS UTRECHT
Exposition poster, 1934
Henri Pieck

JAARBEURS UTRECHT
Exposition poster, 1936
Henri Pieck

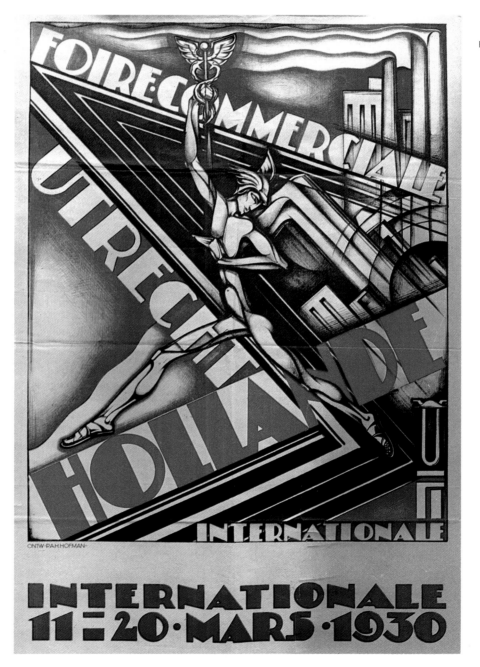

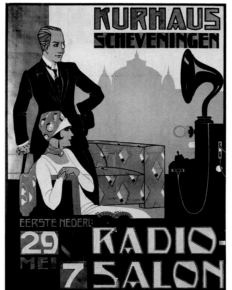

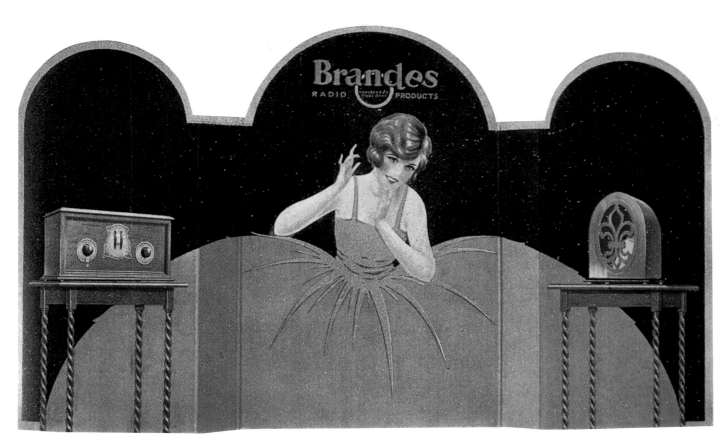

BRANDES
Counter display for radios, c. 1929

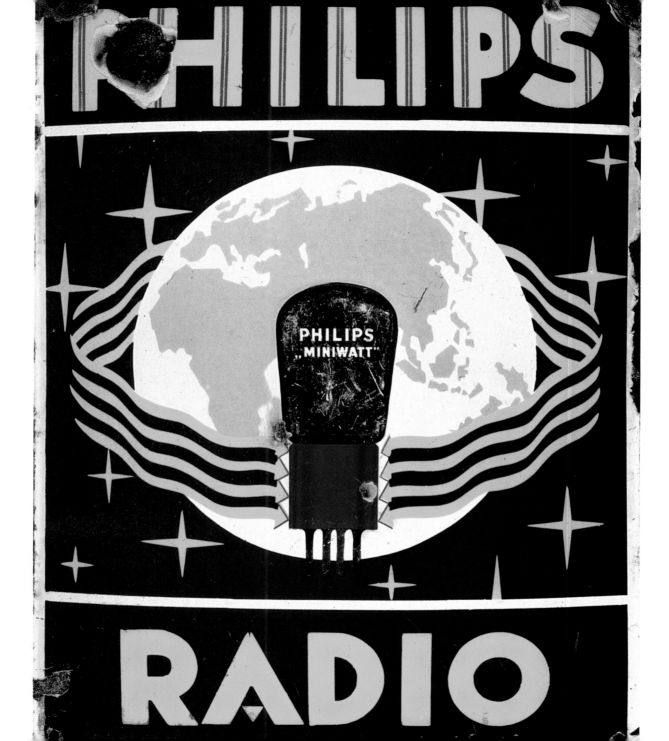

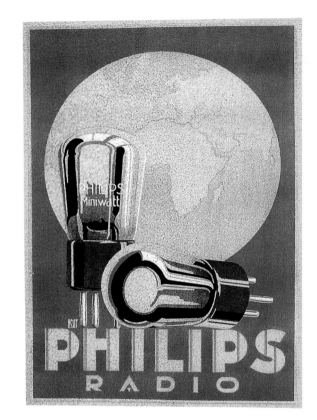

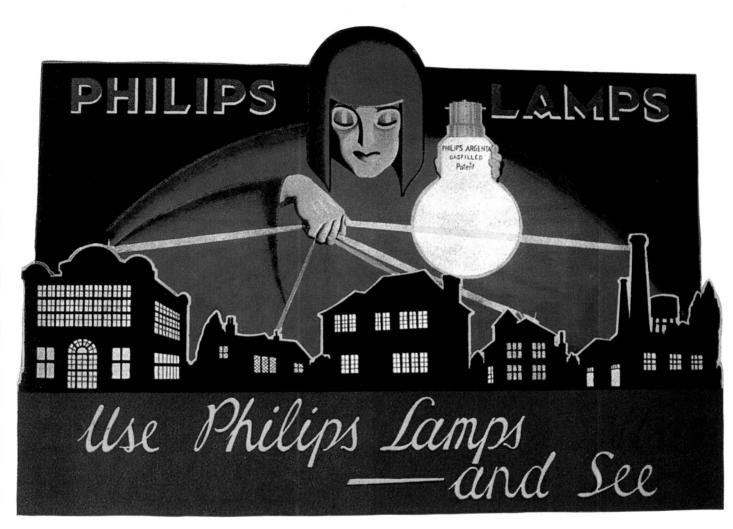

PHILIPS LAMPS
Counter display, 1929

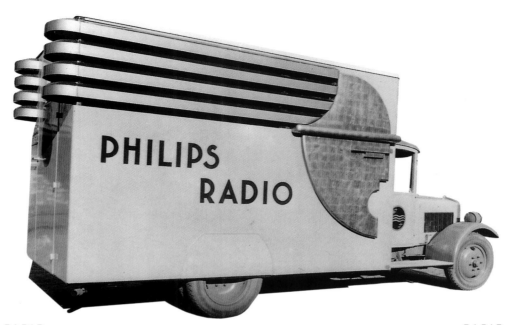

PHILIPS RADIO
Advertising truck, c. 1928

RADIO EXPRES
Magazine cover, 1938

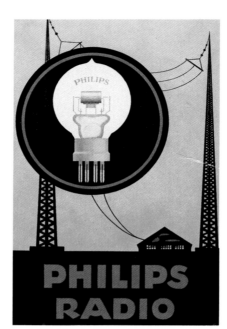

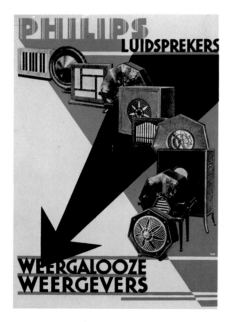

PHILIPS
Loudspeaker poster, 1930

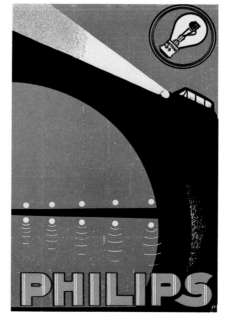

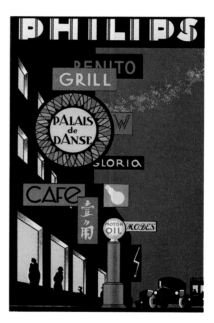

PHILIPS
Autolight poster, c. 1920

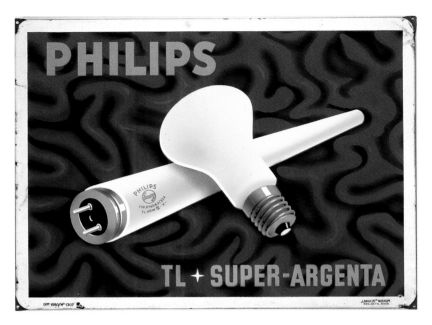

PHILIPS

Lighting poster, c. 1940

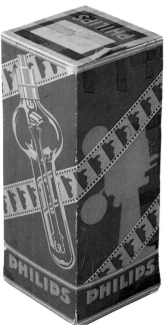

PHILIPS

Package for film projector light, c. 1925

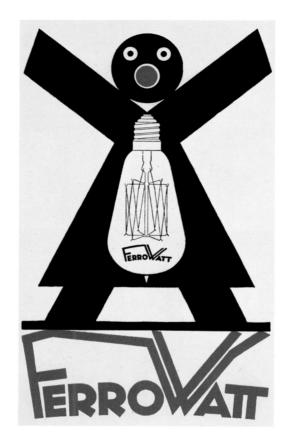

FERROWATT
Lightbulbs advertisement, c. 1930
Julius Klinger

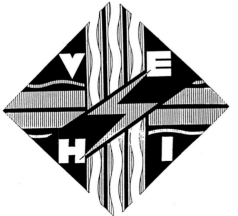

VEHI
Electrical products trademark, 1932

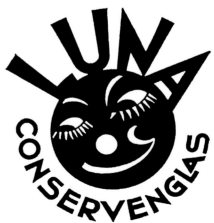

LUNA
Glass trademark, 1935

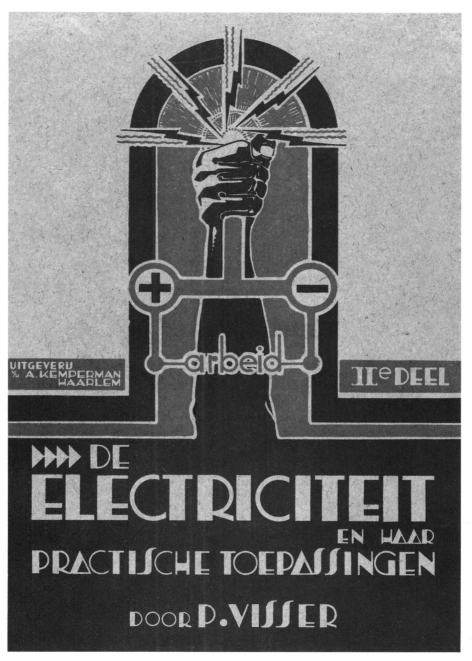

DE ELECTRICITEIT
Book jacket for electronics
manual, 1925

H . BODE
Lamp advertisement,
1924
E. Stroomberg

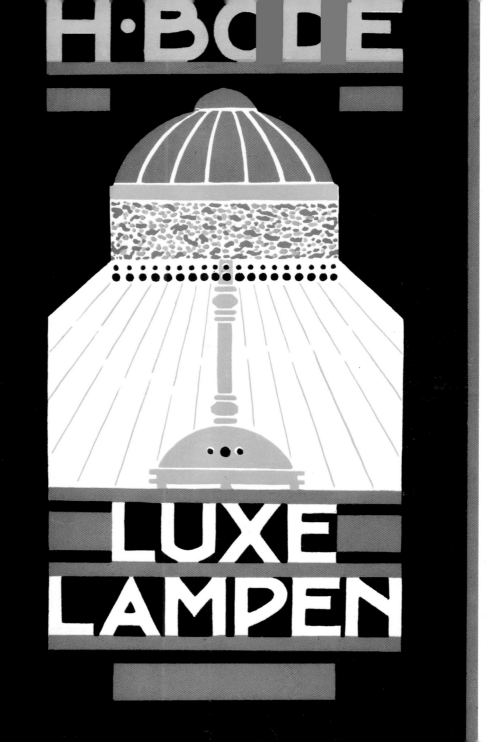

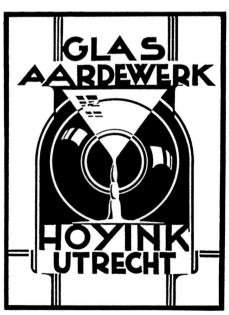

MODERN GLASWERK
Glass advertisement, 1933
J. J. Gramsma

GOUDA KAARSEN
Candle advertisement, 1937
Gerard Hurkmans

GLAS AARDEWERK
Glass advertisement, 1933
Piet Broos

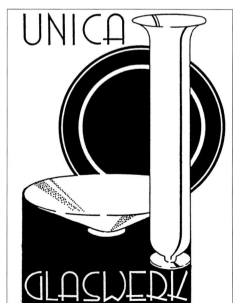

UNICA GLASWERK
Glass advertisement, 1936
Gerard Hurkmans

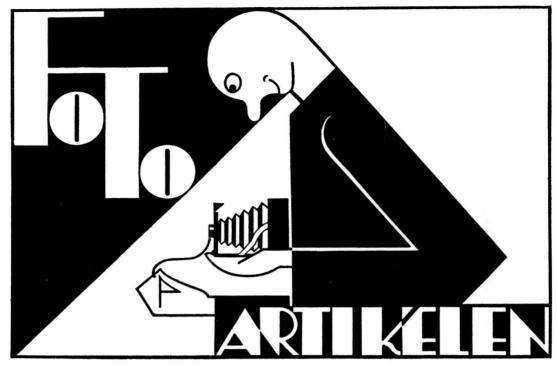

FOTAX

FOTO ARTIKELEN
Advertisement for photo supply store, 1932
W. Heijnen

FOTAX
Photo equipment trademark, 1930

PERFECTA
Magnet trademark, 1938

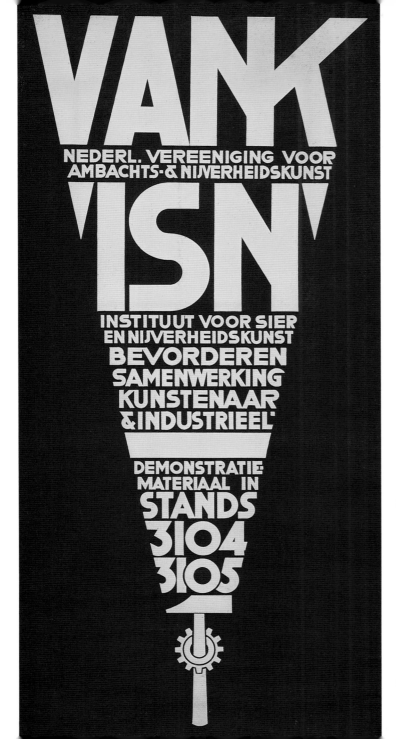

VANK
Industrial fair poster, 1924
Nicolaas P. de Koo

HARLEKIJN SPELEN
Toy trademark, 1934

JEVEA
Motor parts trademark, 1931

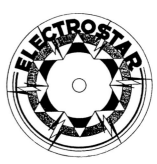

ELECTROSTAR
Record company trademark, 1931

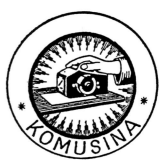

KOMUSINA
Writing machine trademark, 1930

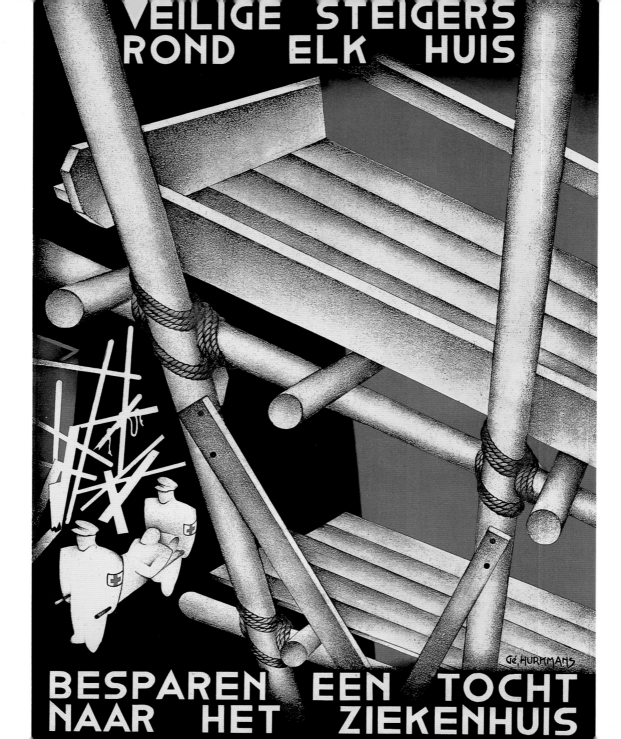

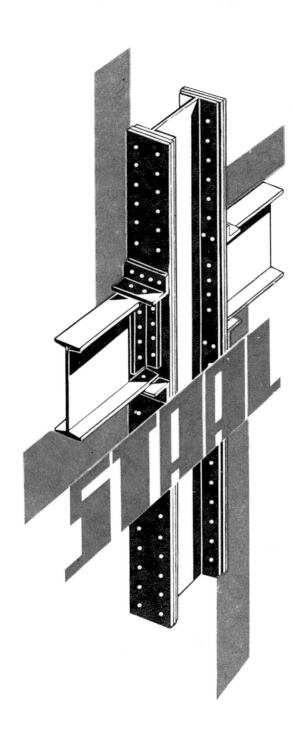

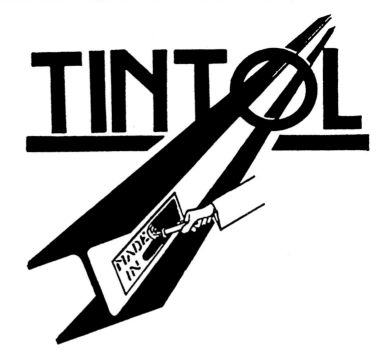

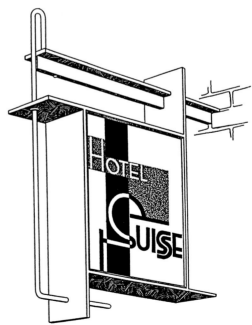

(Opposite)

VEILIGE STEIGERS ROND ELK HUIS
Work safety poster, c. 1939
G. E. Hurkmans

STAAL
Cover for steel manufacturer's
catalog, c. 1930

TINTOL
Paint trademark, 1930

HOTEL SUISSE
Sketch for neon sign, 1934
W. Heijnen

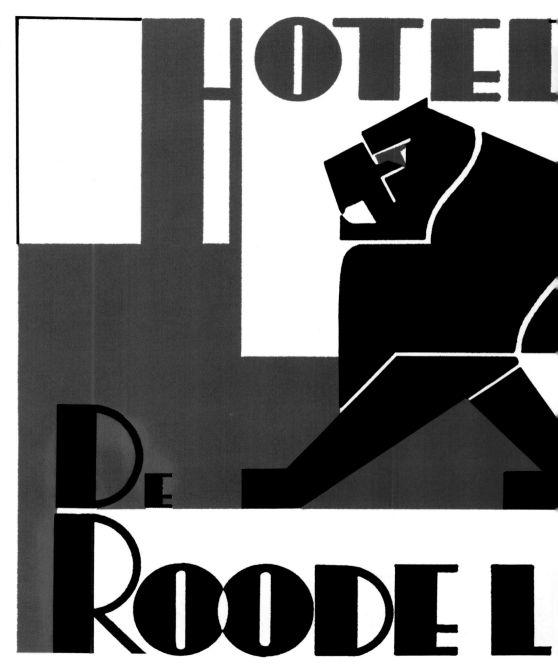

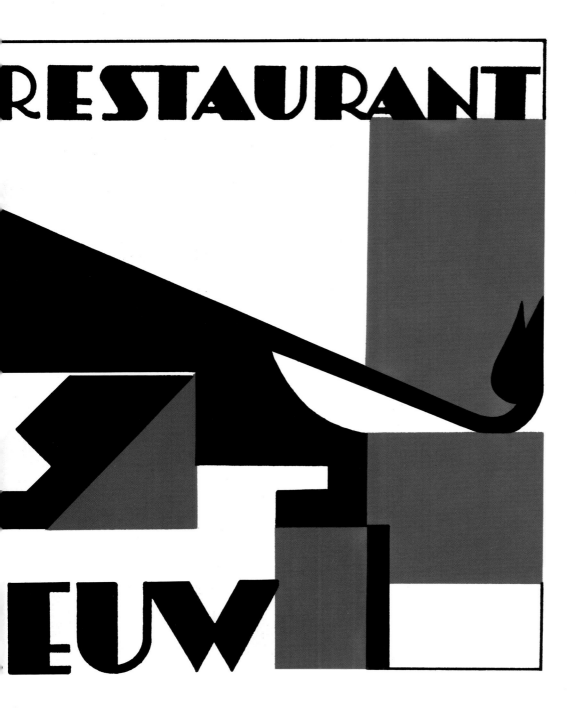

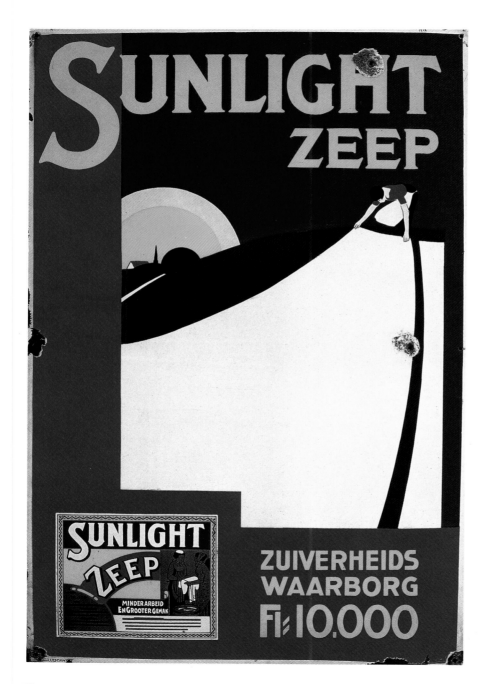

SUNLIGHT ZEEP
ZUIVERHEIDS WAARBORG Fl 10.000

SUNLIGHT ZEEP
MINDER ARBEID EN GROOTER GEMAK

SUNLIGHT ZEEP
Enamel sign for soap, 1920
M. Güthschmidth

MAAS TUNNEL
Radio battery trademark, 1937

TRIOMPHONE
Loudspeaker trademark, 1927

NEUROKARDIN
Pharmaceutical trademark, 1921

P. A. HOUBERG DROGISTERY
Pharmaceutical trademark, 1930

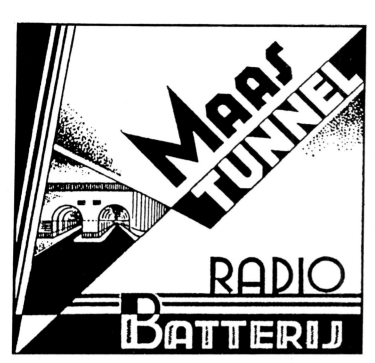

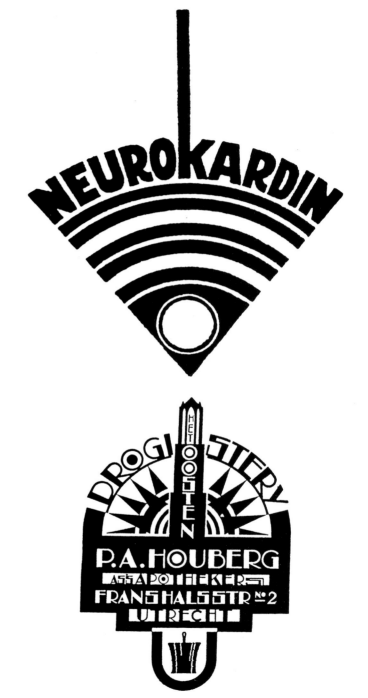

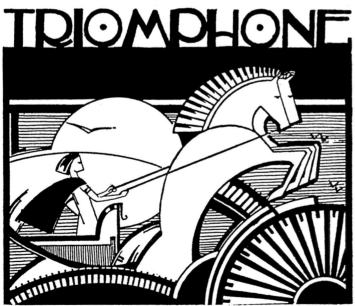

Of the many foods and beverages for which Holland is renowned, none is more celebrated than its beers. It might therefore be expected that in a country of many competing brands advertisments for this product would be superb, but surprisingly, beer and **FOOD & DRINK** liquor promotions were not always well done. Only a few of the major breweries and distilleries transcended the unimaginative convention of showing a product. Most notable was Nicolaas P. de Koo's campaign for Phoenix Dort-munder beer which combined traditional illustration with modern typography to form a rebus. Yet the most distinctive and adventuresome campaign was seen in Jac. Jongert's posters, packaging, and advertisements for Van Nelle coffees and teas which present De Stijl-inspired geometry and a primary-color palette with a modernistic sensibility. Van Nelle was in the vanguard of modern design: its packages designed in keeping with avant-garde styles, but, even more significant, its glass-walled factory, designed in 1930, is a monument to classical modernism. Reflecting current styles, many other products, including Dutch chocolates, milk, and biscuits, were packaged and promoted through highly decorative modernistic design, though rarely with the devotion to nuance of the Van Nelle graphics.

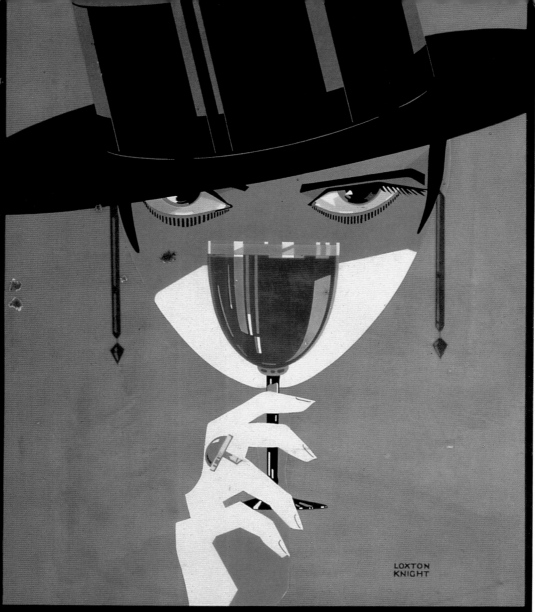

SANDEMAN'S
PORT

SANDEMAN'S
PORT
Enamel sign for
Seagram Nederland,
1925
After Laxton Knight

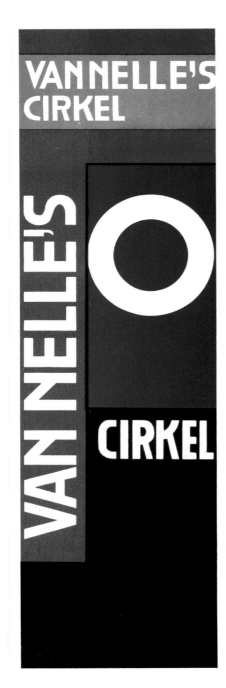

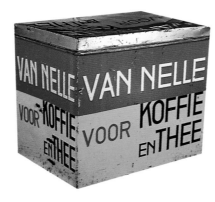

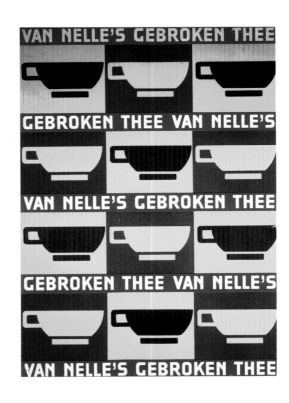

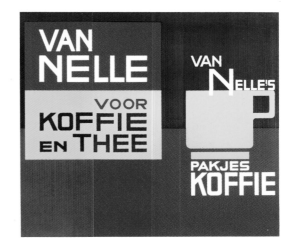

VAN NELLE'S CIRKEL
Coffee advertisement, c. 1930
Jac. Jongert

VAN NELLE'S GEBROKEN
Tea poster, 1929
Jac. Jongert

VAN NELLE
Coffee and tea tin, c. 1930
Jac. Jongert

VAN NELLE
Coffee and tea poster, 1931
Jac. Jongert

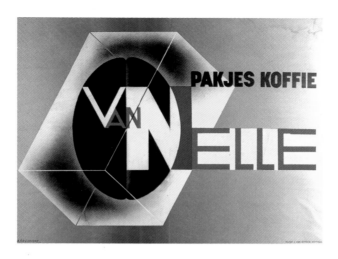

VAN NELLE
Coffee poster, 1931
A. M. Cassandre

VAN NELLE'S
Coffee poster, 1933
Jac. Jongert

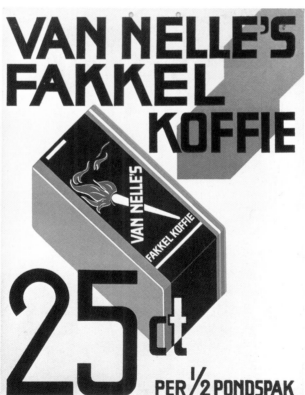

DROSTE
Chocolate trademark, 1931

BENSDORP
Chocolate trademark, 1927

DE BRAAM
BRUMMEN
Coffee and tea trademark,
1932

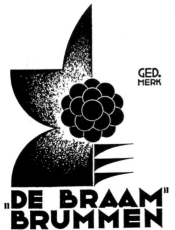

VAN VEKA
Coffee and tea
advertisement, 1937
P. Broos

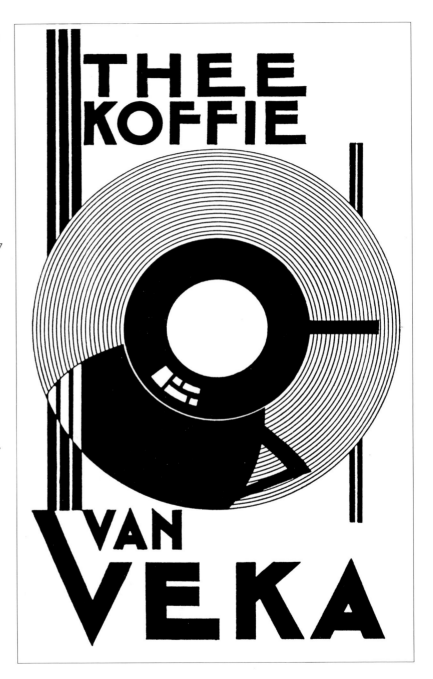

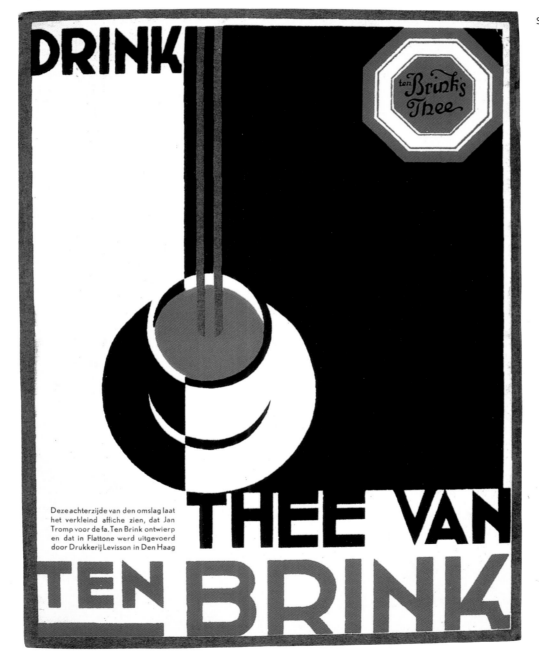

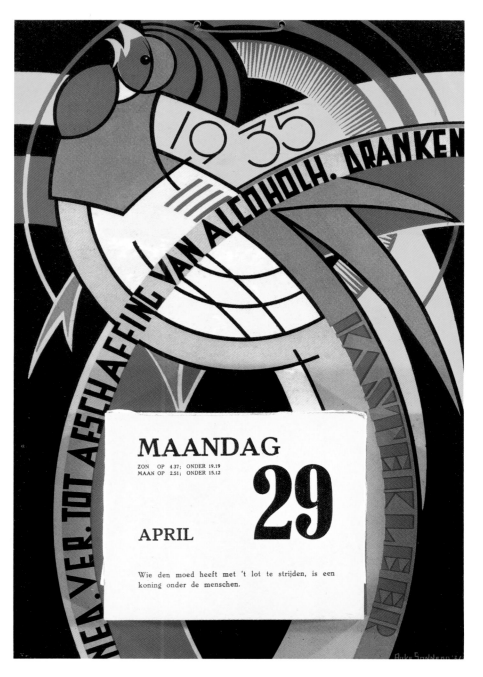

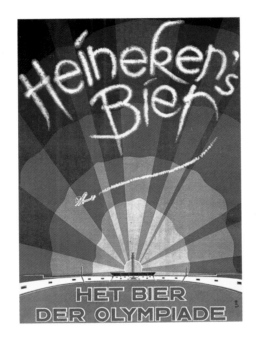

HEINEKEN'S BIER
Beer poster, c. 1928

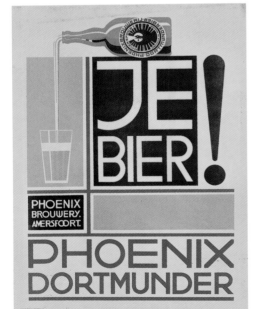

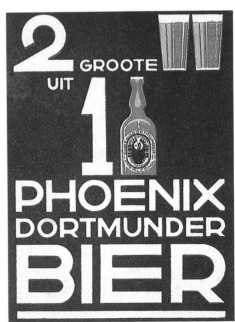

PHOENIX DORTMUNDER
Beer posters, c. 1928
Nicolaas P. de Koo

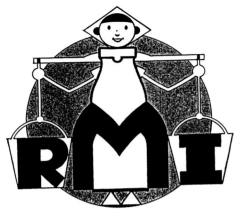

R M I
Dairy trademark, 1934

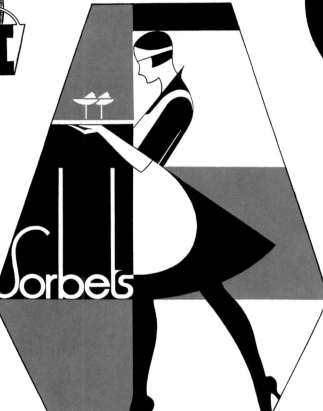

S O R B E T S
Ice cream trademark, 1931
W. Heijnen

W A
Grocery trademark, 1936

L O N N E K E R
Dairy trademark, 1941

E P C O
Grocery trademark, 1938

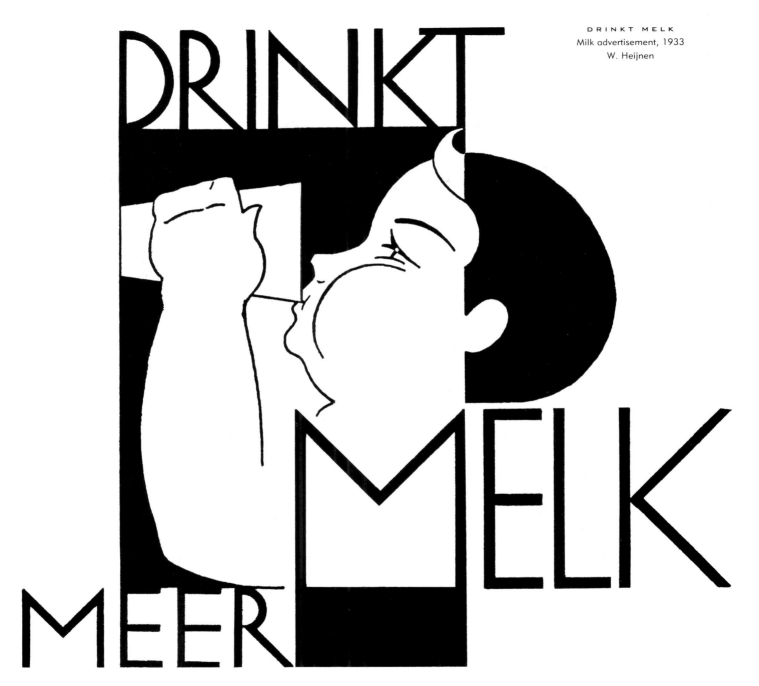

DRINKT MELK
Milk advertisement, 1933
W. Heijnen

FIRMA
G·DANEELS

BROOD·KOEK·EN
BANKET·BAKKER

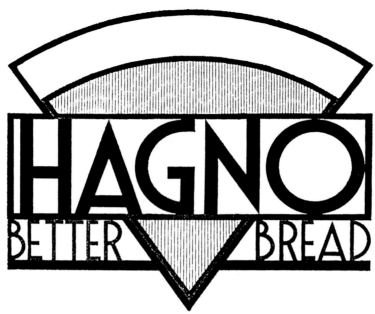

HAGNO

Bakery trademark, 1932

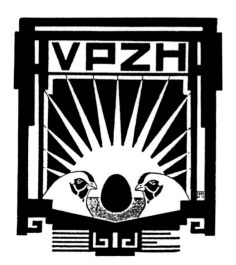

VPZH

Poultry trademark, 1927

GL

Bakery trademark, 1931

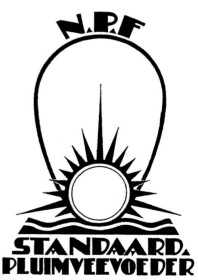

NPF

Poultry trademark, 1928

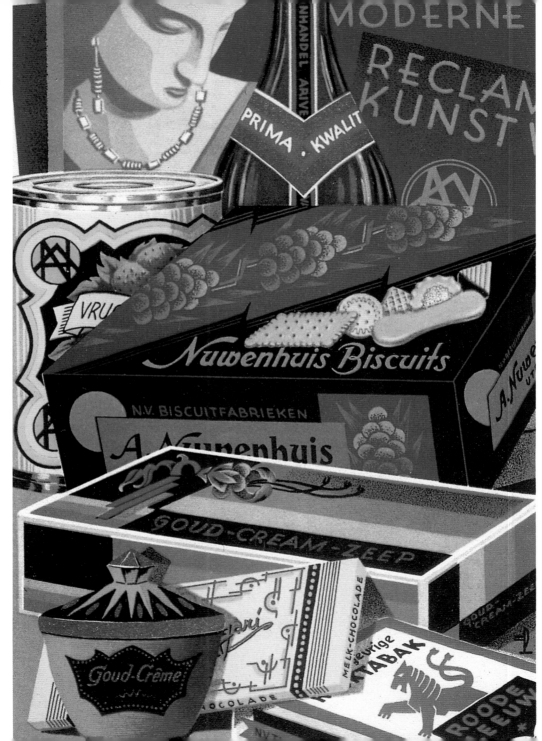

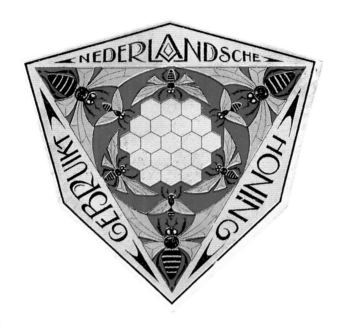

NEDERLANDSCHE HONING
Honey label, c. 1930

RINGERS ORLACTA
Chocolate label, 1926

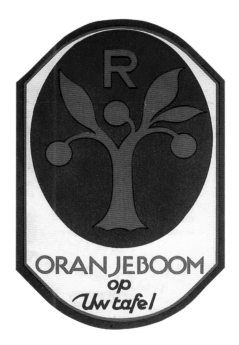

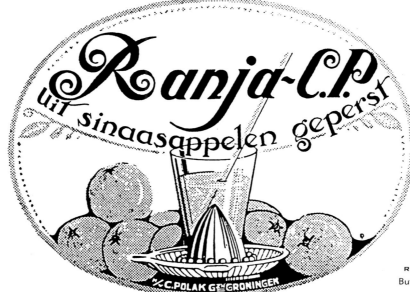

94

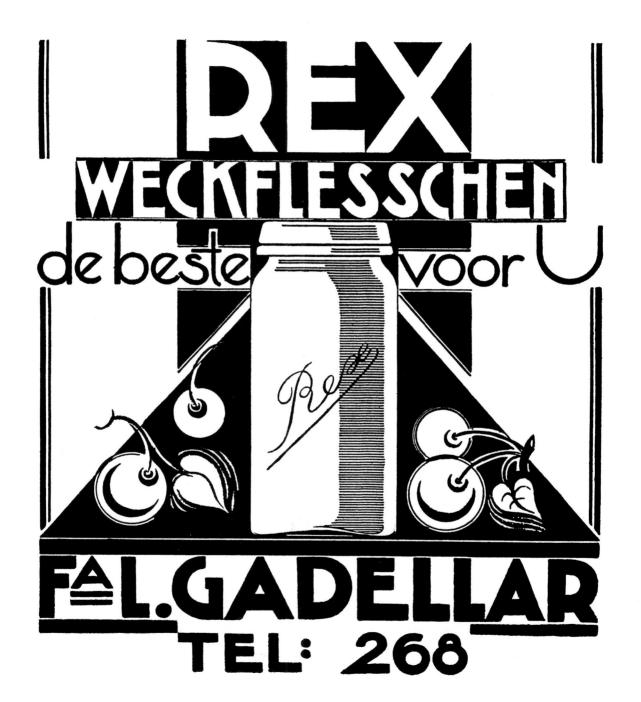

SINCE EUROPE FOR DECADES HAS BEEN THE WORLD'S LARGEST CONSUMER OF COMMERCIAL TOBACCO PRODUCTS, IT IS NO WONDER THAT MANUFACTURERS OF CIGARETTES, CIGARS, AND PIPE TOBACCO COMPETED FIERCELY DURING THE 1920S AND 1930S. HUNDREDS OF LARGE AND SMALL **TOBACCO** COMPANIES FOUGHT FOR CUSTOMERS THROUGH ADVERTISING AND PROMOTION. ALTHOUGH VARIOUS FORMATS WERE USED AND VIRTUALLY ANY STYLE WOULD DO, ART MODERNE PERFECTLY PROJECTED THE IMAGE OF ELEGANCE AND PLEASURE TO BE DERIVED FROM SMOKING. ALTHOUGH THE NETHERLANDS DID NOT EXCEED OTHER EUROPEAN COUNTRIES IN TOBACCO CONSUMPTION, ONE DUTCH MANUFACTURER WAS EUROPE'S MASTER AT ADVERTISING AND PACKAGING. AS IT DID FOR COFFEES AND TEAS, VAN NELLE PRODUCED SOME OF THE MOST MEMORABLE PROMOTIONS FOR TOBACCO PRODUCTS. FROM SHINY ENAMEL STREET SIGNS TO LAVISH COUNTER DISPLAYS, FROM STARTLING POSTERS TO COMMON CAFÉ CHECKS AND RECEIPTS, VAN NELLE USED THE MOST CONTEMPORARY STYLES IN THE MOST INVENTIVE, EYE-CATCHING DISPLAYS TO PLASTER ITS NAME THROUGHOUT HOLLAND. WHETHER BY ACCIDENT OR DESIGN, AND WITHOUT EVER EVEN SHOWING A CIGARETTE OR A PERSON SMOKING IT, VAN NELLE IMBUED ITS PRODUCTS WITH AN UNFORGETTABLE AURA OF SOPHISTICATION.

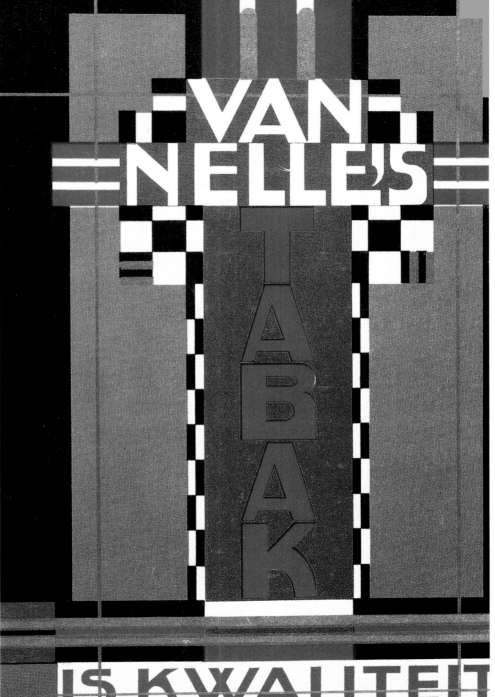

VAN NELLE'S
Tobacco poster, c. 1929
Jac. Jongert

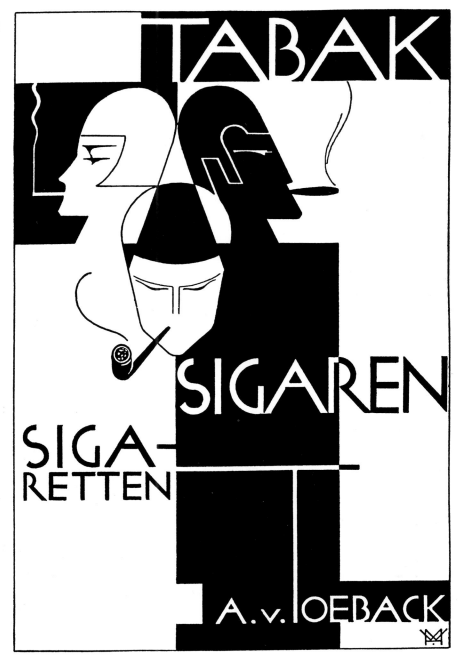

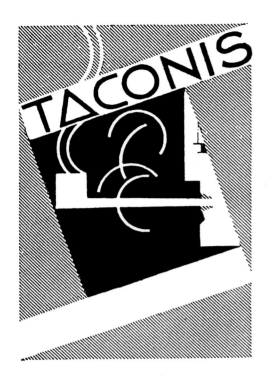

TACONIS
Pipe advertisement, 1931

MONTE CARLO
Cigarette trademark, 1936

TABAK
Pipe tobacco trademark, 1937

J. F. HERMAN
& ZN. HILVERSUM
Pipe tobacco trademark, 1929

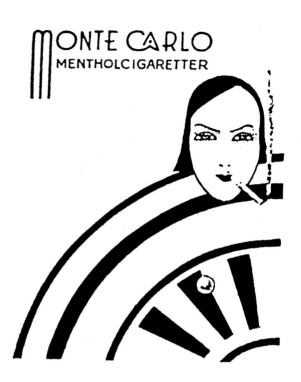

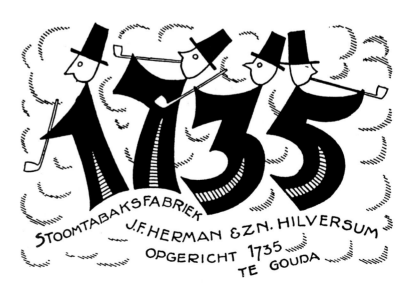

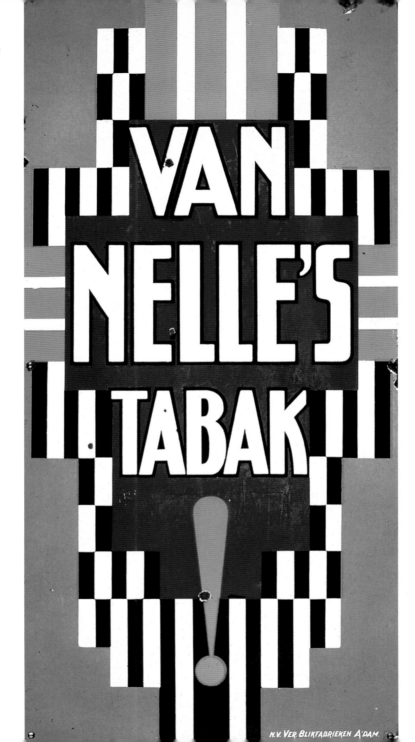

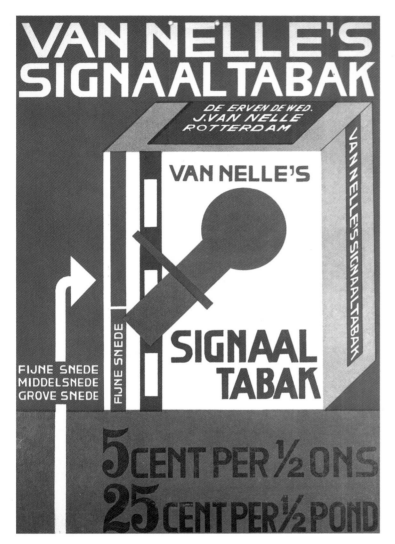

VAN NELLE'S SIGNAAL TABAK
Tabacco advertisement, 1927
Jac. Jongert

VAN NELLE'S TABAK
Restaurant check, c. 1926
Jac. Jongert

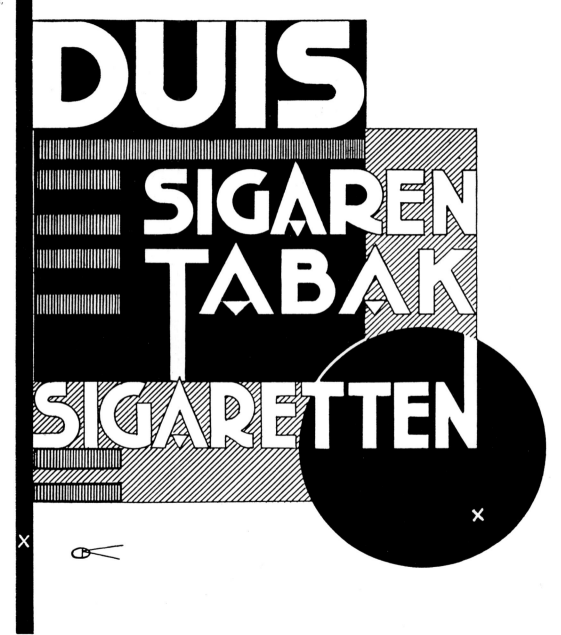

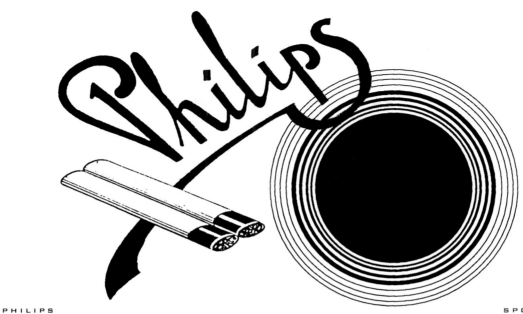

PHILIPS
Cigarette trademark, 1922

SPOORTABAK
Cigarette trademark, 1927

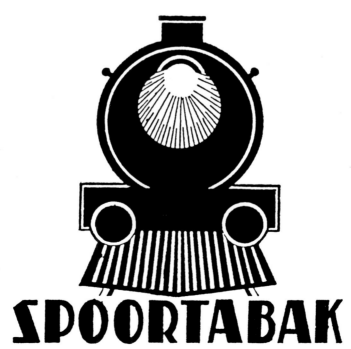

By train, ship, plane, and car, tourists from all over Europe and the United States have for decades made the Netherlands their destination. As centers of trade, Holland's large ports have also been the debarkation points for both cruise and transport ships. **TRAVEL** Advertisements for ocean travel became one of Holland's earliest poster genres. While many of the most striking cruise posters were based on French models, notably A. M. Cassandre's 1929 cubist-inspired poster for the Statendam steamship, Dutch designers developed their own rectilinear mannerisms, influenced by the Wendingen style. After ships, the most common travel image was the airplane. In the age of flight, advertisements for KLM (Royal Dutch Airways) used art moderne to portray the essence of speed — and progress. Both the ship and the plane, with their sleek silhouettes, seemed perfectly suited for modernistic representation. Another common genre was the train poster, representing the primary method of low-budget, high-speed transportation. Trains were presented through impressive graphic personifications of the locomotive, epitomizing the glory of the Machine Age. And not least important, the automobile was routinely celebrated in graphics expressing speed combined with personal comfort.

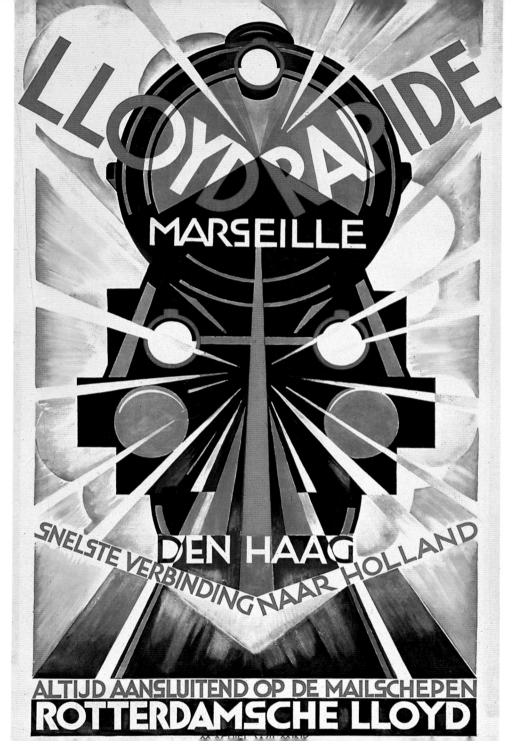

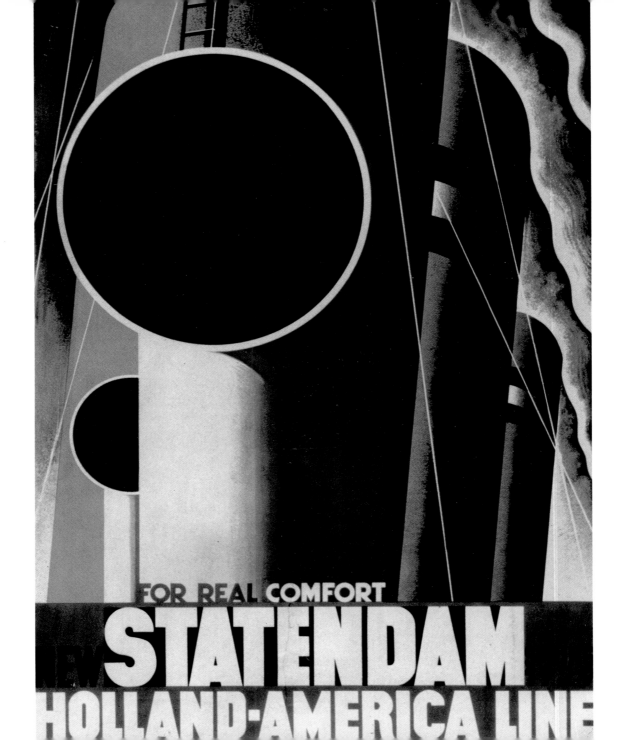

FOR REAL COMFORT
STATENDAM
HOLLAND-AMERICA LINE

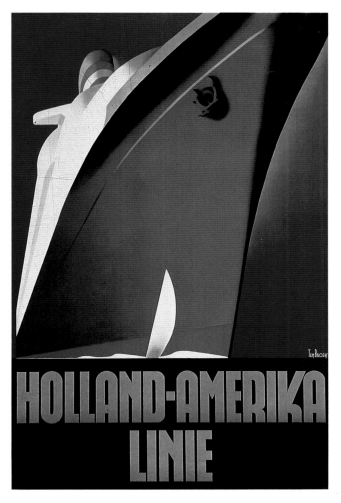

HOLLAND-AMERIKA LINIE
Travel poster, 1936
Wim ten Broek

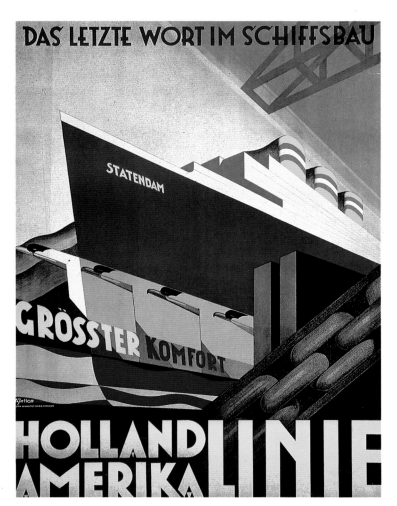

HOLLAND-AMERIKA LINIE
Travel poster, 1925
Adriaan Joh. van't Hoff

STATENDAM
Travel poster, 1929
A. M. Cassandre

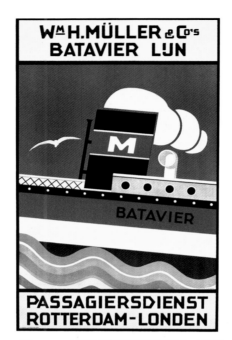

WM. H. MÜLLER & CO.'S
BATAVIER LIJN
Travel poster, c. 1928
C. Claussen

NACH ENGLAND
Travel poster, 1927
Austin Cooper

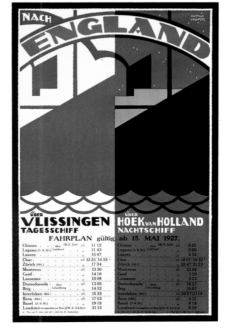

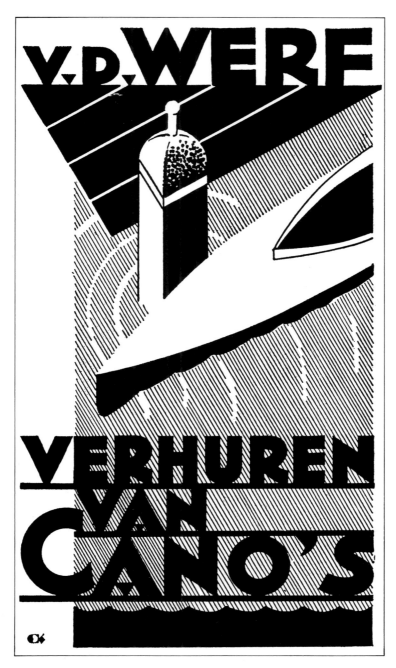

V.D. WERF
Boat advertisement, 1935
O. Kerseen

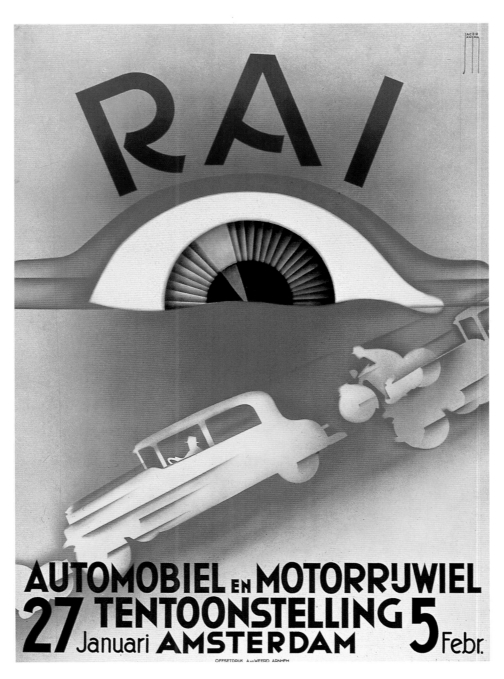

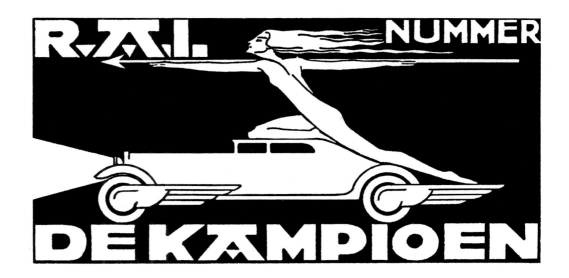

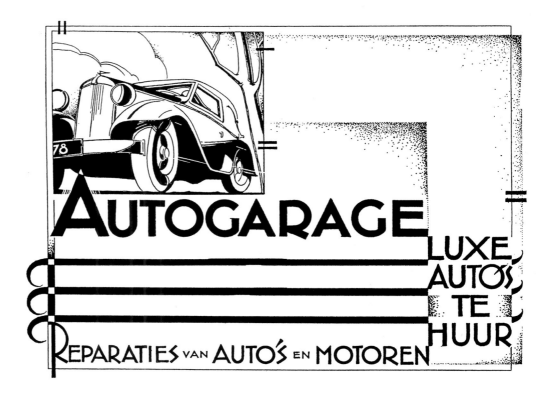

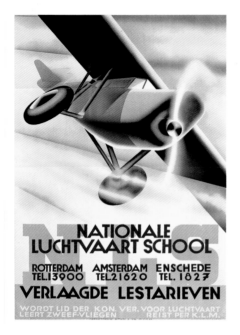

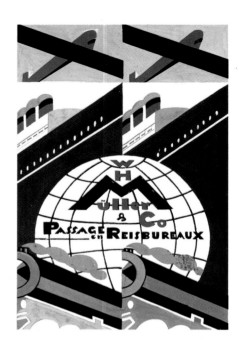

NATIONALE LUCHTVAART
SCHOOL
Aviation school poster, c. 1933
Kees van der Laan

W.H. MULLER & CO.
Sketch for travel poster (painting), 1930
Franciska Clausen

K.L.M.
Airline poster, 1934
Machteld den Hertog

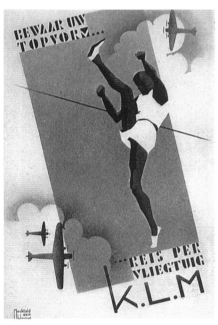

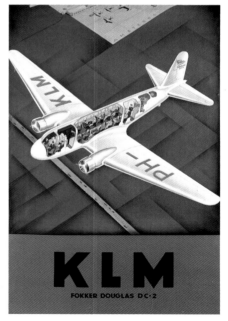

K.L.M. FOKKER
DOUGLAS DC-2
Airline poster, c. 1937

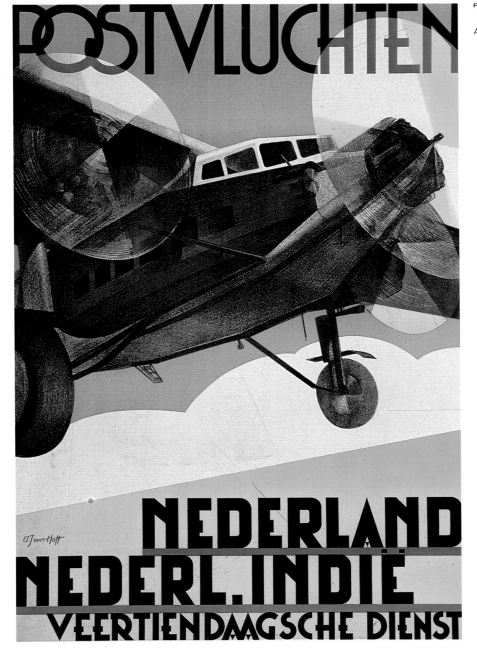

POSTVLUCHTEN
Airline poster, 1933
Adriaan Joh. van't Hoff

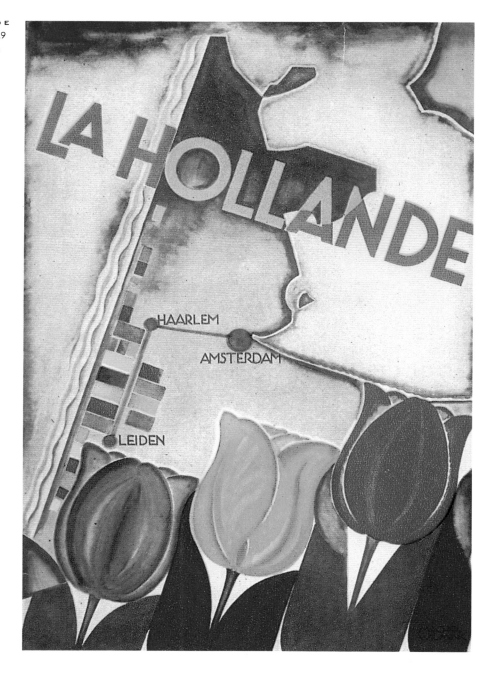

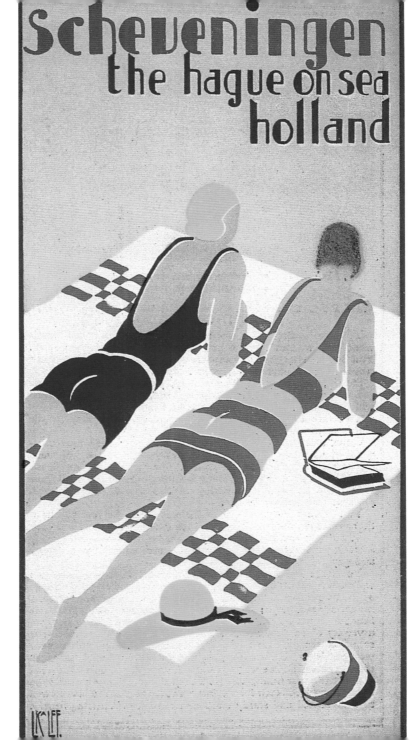

SCHEVENINGEN
Resort poster, 1931
Louis Kalff

The renaissance of Dutch typography in the early twentieth century sprang from both the resurgence of traditional forms and the development of avant-garde approaches. The traditionalists believed that the most functional typography was elegant TYPOGRAPHY and "invisible." They reevaluated typographic standards with the primary goal of providing the writer with the tools of communication. The avant-garde believed that type had an autonomous function, and they used all available means to emphasize "expressive, associative, and plastic possibilities with the forms of letters themselves" (Kees Boos, in Friedman, 1982). The traditionalists reestablished order and created a need for serious typographers in a field debased by poor aesthetics; the modernists tested the limits of typographic expression and pushed the boundaries of plastic form. Tucked between the two extremes was an eclectic manner used by the majority of Dutch businesses for advertising and logos. Some typographic innovations were influenced by the two formal schools, but most were untheoretical solutions to commercial problems. The lettering ranged from the unrepentantly old-fashioned to the proudly expressionistic. Of these, the ones that were distinctly Dutch evolved from Wendingen style decorativism.

Kukileg

Frapanto

Petrus Camper

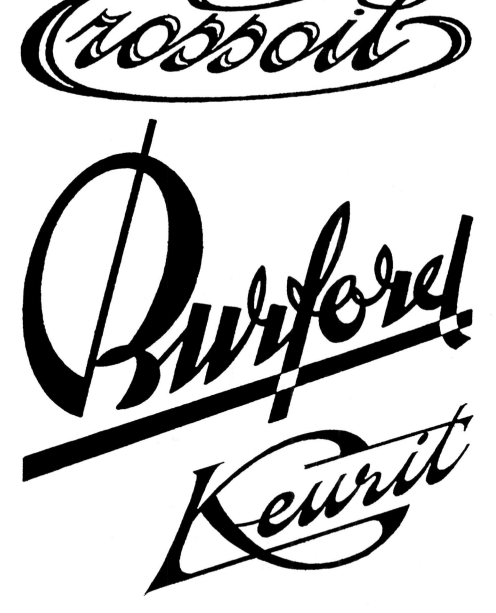

BURFORD
Haberdashery trademark, 1930

KEURIT
Dental supply trademark, 1931

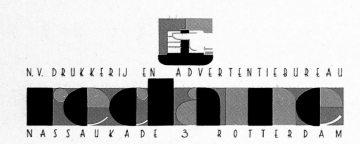

N.V. DRUKKERIJ EN ADVERTENTIEBUREAU

NASSAUKADE 3 ROTTERDAM

TEL. 27360. TELEGR. ADRES: PROGRESS-ROTTERDAM. POSTBUS 160.

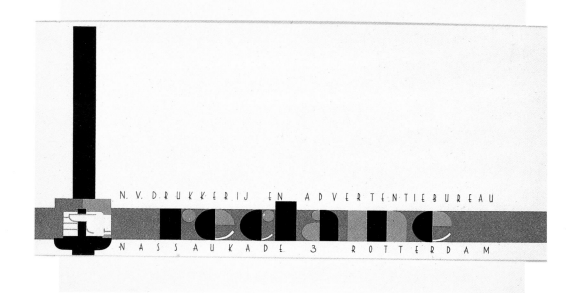

No. 6 · ● 6e JAARGANG
● MAART 1936 ●

Germania

GERMANIA
Masthead for sports magazine,
1936

DE PROLETARISCHE VROUW

BLAD VOOR ARBEIDSTERS EN ARBEIDERSVROUWEN, WEEKBLAD VAN DEN BOND VAN SOC·DEM·VROUWEN·PROPAGANDA·CLUBS IN NEDERLAND

ONDER REDACTIE VAN C. POTHUIS · SMIT

DE PROLETARISCHE VROUW
Masthead for working women's
newspaper, 1929

GEÏLLUSTREERD SCHILDERSBLAD

UITGAVE DRUKKERIJ EISMA LEEUWARDEN

GEÏLLUSTREERD SCHILDERSBLAD
Masthead for housepainters'
magazine, 1940

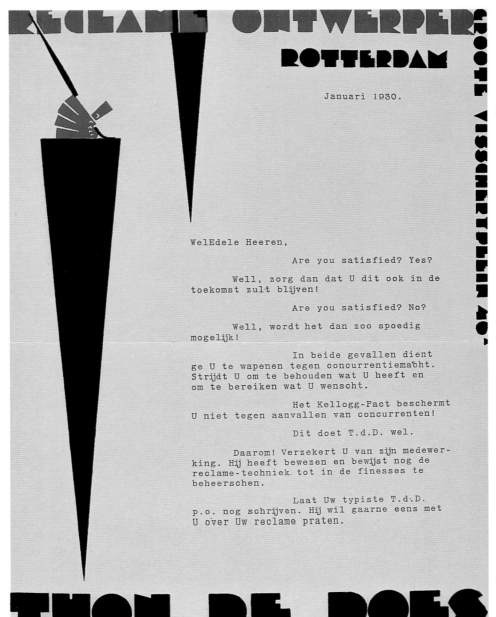

RECLAME ONTWERPER

ROTTERDAM

GROOTE VISSCHERIJPLEIN 40

Januari 1930.

WelEdele Heeren,

Are you satisfied? Yes?

Well, zorg dan dat U dit ook in de toekomst zult blijven!

Are you satisfied? No?

Well, wordt het dan zoo spoedig mogelijk!

In beide gevallen dient ge U te wapenen tegen concurrentiemacht. Strijdt U om te behouden wat U heeft en om te bereiken wat U wenscht.

Het Kellogg-Pact beschermt U niet tegen aanvallen van concurrenten!

Dit doet T.d.D. wel.

Daarom! Verzekert U van zijn medewerking. Hij heeft bewezen en bewijst nog de reclame-techniek tot in de finesses te beheerschen.

Laat Uw typiste T.d.D. p.o. nog schrijven. Hij wil gaarne eens met U over Uw reclame praten.

THON DE DOES

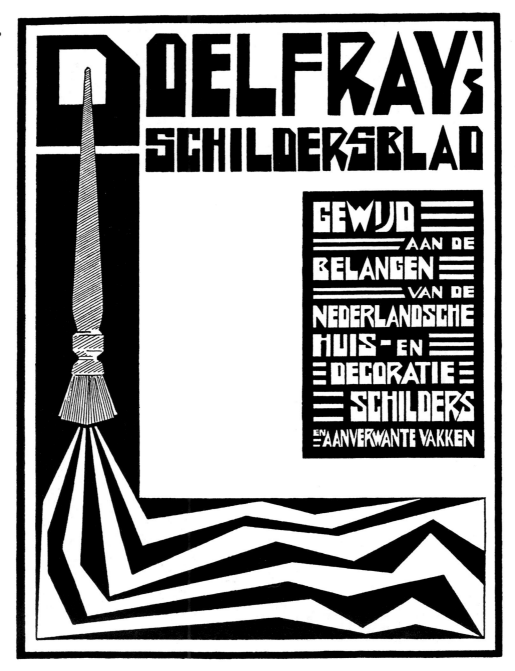

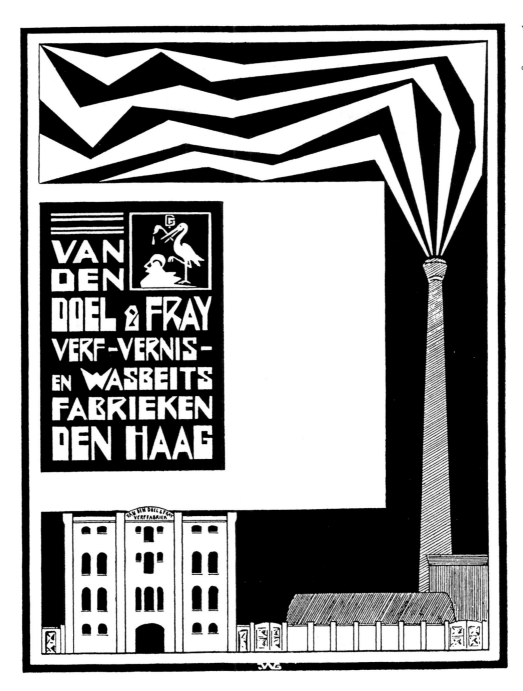

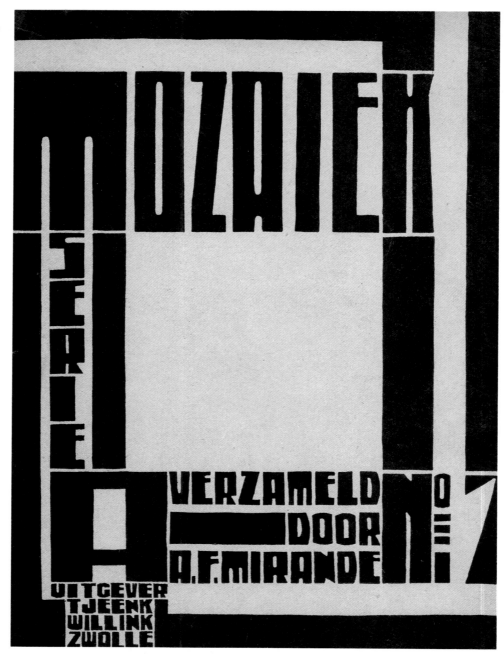

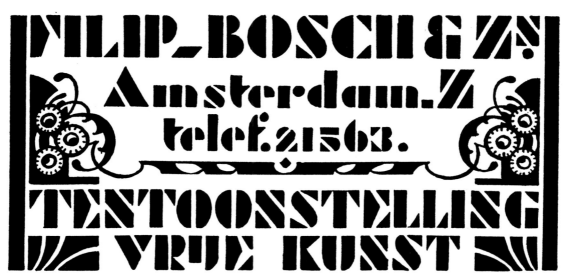

FILIP BOSCH & ZS.
Art gallery business card, 1930

BETONOPZETTERS
Concrete advertisement, 1926

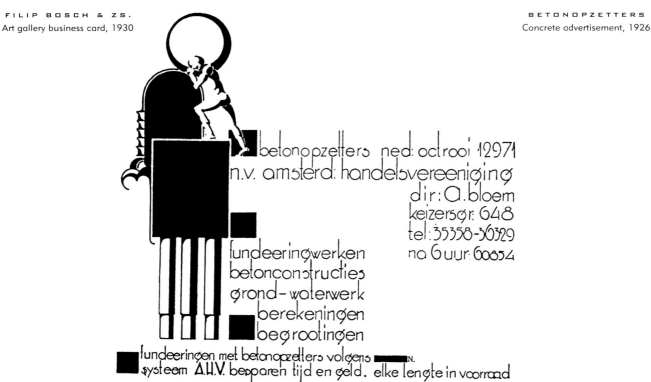

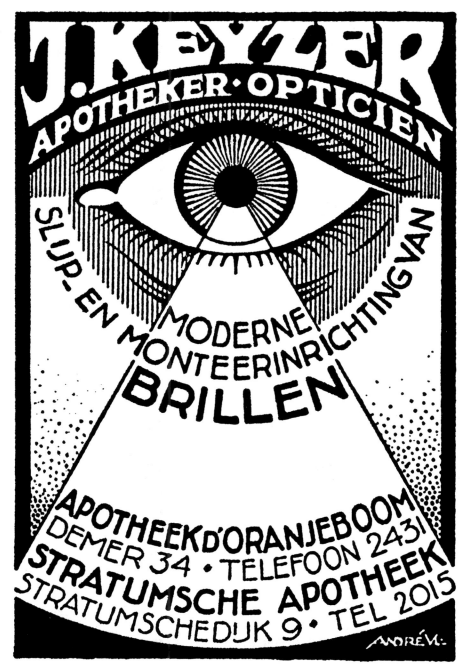

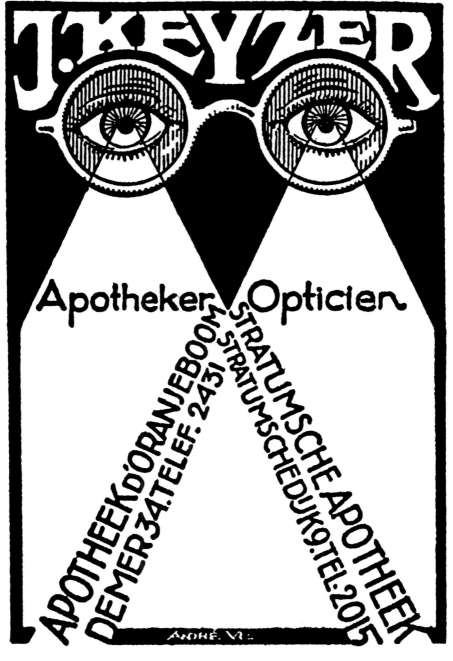

LICONA

PERLA

PERPLEX

LICONA
Fabric trademark, 1929

PERLA
Soap trademark, 1929

PERPLEX
Carpenter's trademark, 1930

P. VAN BERKEL LTD.
Meat advertisement, c. 1925
Paul Schuitema

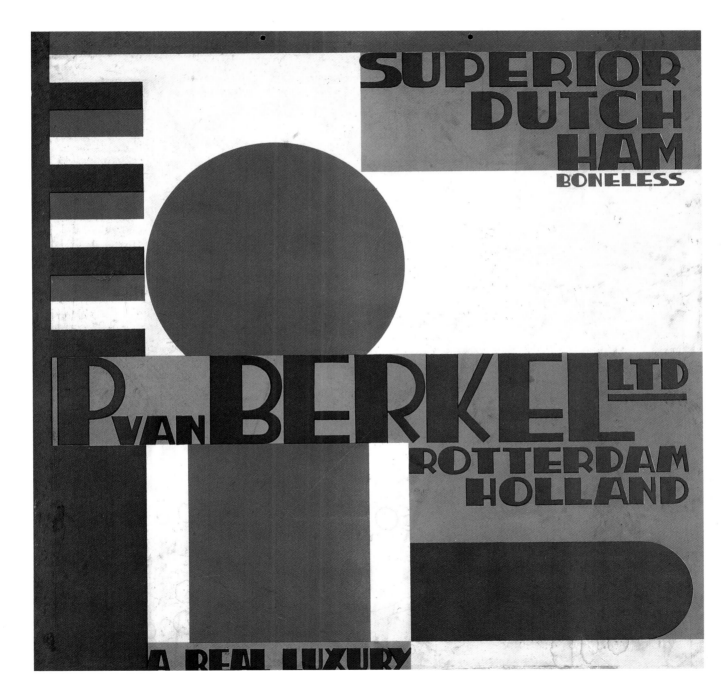

BIBLIOGRAPHY

Bekooy, Buss. Philips Hondred (1891-1991): Een industriële onderneming. Eindhoven: Europese Bibliotheek Zaltbommel, 1991.

Bosters, Cassandra. Ontworpen voor de jaarbeurs: 75 jaar koninklijke Nederlandse jaarbeurs. Utrecht: Walburg Pers/Centraal Museum Utrecht, 1991.

Dooijes, Dick. "Typography for Today." Delta: A Review of Arts, Life, and Thought in the Netherlands, 3, no. 2. Amsterdam: Delta, 1960.

———. Wegbereiders van de moderne boektypografie in Nederland. Amsterdam: De Buitenkant, 1988.

Dooijes, Dick, and Pieter Brattinga. A History of the Dutch Poster, 1890-1960. Amsterdam: Scheltema and Holkema, 1968.

Egbers, Henk. Koffie in de kunst. Wert: Van Nelle. Rotterdam: Douwe Egberts Van Nelle, 1986.

Elzinga, D. J., and G. Voerman. Om de stembus... verkiezingsaffiches. The Hague: Sdu Uitgeverij Koninginnegracht, 1992.

Franciscono, M., and Stephen S. Prokopoff. The Modern Dutch Poster. Champaign, Ill.: Krannert Art Museum and Cambridge, Mass.: M.I.T. Press, 1987.

Friedman, Mildred, ed. De Stijl 1917-1931, Visions of Utopia. New York: Abbeville Press, 1982.

Hefting, Paul. PTT: Art and Design, Past and Present. Amsterdam: PTT Nederland, 1992.

Jaffé, H. L. C. De Stijl 1917-1931. Cambridge, Mass.: Harvard University Press, Belknap Press, 1986.

Leidelmeijer, Frans. Art nouveau en art deco in Nederland. Amsterdam: Meulenhoff/Landshoff, 1983.

Maan, Dick, and John van der Ree. Typo-foto/elementaire: Typografie in Nederland 1920-1940. Utrecht and Antwerp: Veen Reflex, 1990.

Portoghesi, Paolo, and Giovanni Fanelli. Wendingen. Florence: Franco Maria Ricci, 1988.

Purvis, Alston. Dutch Graphic Design 1918-1945. New York: Van Nostrand Reinhold, 1992.

Van Faassen, Egbert. Drukwerk voor PTT. Mermano: Rijks Museum Mermanno-Westreenianum, 1988.